THE CHANGING]

CW00503852

St Ebbe's and St Thomas

BOOK TWO

Carole Newbigging

Robert Boyd
PUBLICATIONS

Published by
Robert Boyd Publications
260 Colwell Drive
Witney, Oxfordshire OX8 7LW

First published 1997

Copyright © Carole Newbigging and
Robert Boyd Publications

ISBN: 1 899536 17 5

OTHER TITLES IN THE
CHANGING FACES SERIES

Botley and North Hinksey
Bladon with Church Hanborough
 and Long Hanborough
Cowley: Book One
Cowley: Book Two
Cumnor and Appleton with
 Farmoor and Eaton
Eynsham: Book One
Headington: Book One
Headington: Book Two
Jericho: Book One
Littlemore and Sandford
Marston: Book One
Marston: Book Two

Summertown and Cutteslowe
St Ebbes and St Thomas: Book One
St Clements and East Oxford: Book One
Wolvercote with Wytham and Godstow
Woodstock: Book One
Woodstock: Book Two

Forthcoming

Banbury
Cowley Works
Faringdon
Jericho: Book Two
Kennington
North Oxford

Oxford City Centre
Thame
Walton Manor
West Oxford
Witney

Anyone can publish a book — why not you!
Have you ever wanted to publish a book? It is not as difficult as you might think. The publisher of this book provides a service to individuals and organisations large and small.

 Advice can be given on all facets of production: typesetting, layout and design, paper stocks, styles of binding including wired, perfect, sewn, limp and cased binding, the options are almost endless. If you have a project you would like to discuss why not contact:

Robert Boyd
PRINTING & PUBLISHING SERVICES
260 Colwell Drive
Witney, Oxfordshire OX8 7LW

Printed and bound in Great Britain at The Alden Press, Oxford

Contents

Acknowledgements 6

Section 1 Occupation and Trade 7

Section 2 Pubs and Breweries 25

Section 3 School Days 43

Section 4 Events and People 55

Section 5 Buildings and Views 77

Section 6 Oxford Castle and Mill 91

Cover illustrations

Front: Capes in St Ebbe's Street

Back: Brewery workers at Morrells c1912

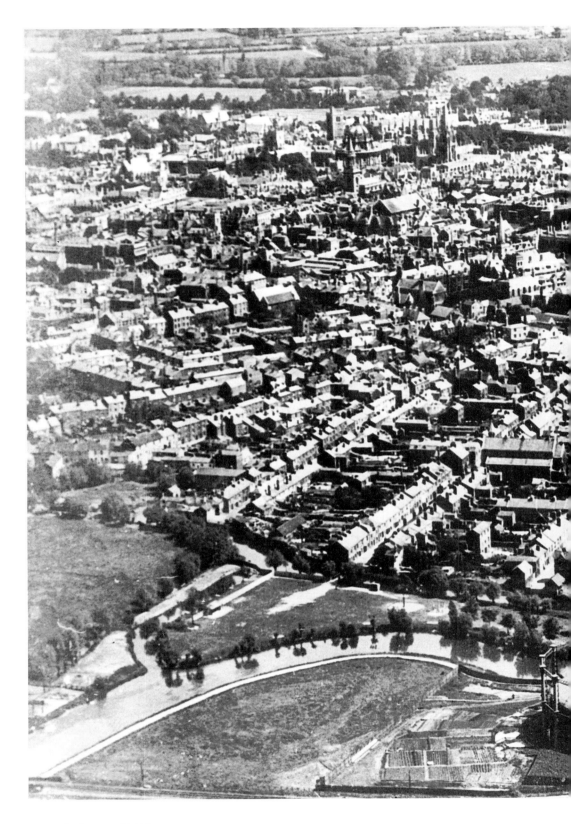

Aerial photo of 1918.

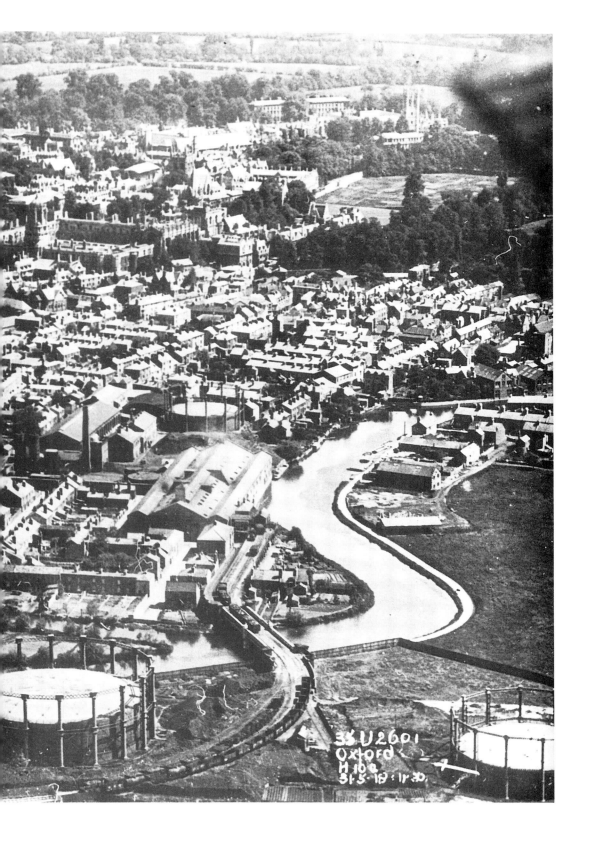

35 U 2601
Oxford
M 10a
31.5.18. 1ᴾ30.

Acknowledgements

My grateful thanks to everyone who contributed material towards this second book on St Ebbe's and St Thomas's, and my apologies to anyone inadvertently omitted:

Doris and Paul Ashmall, Audrey Batts, Colin Bradford, Miss Clarke, Dorothy Durham, Mr T Flatman, Edmund Gibbs, Eric Godfrey, Bill and Margaret Haile, Clive and Audrey Holmes, Joan Howard-Drake, Jean Kearley, John Kirby, Brian Lowe, Rosemary Marshall, Gwen Morris, John and Lily Mutton, Peter Patrick, Mrs I Phillips, Mrs Purves, Ron Robinson, Bryan and John Rowland, Derek Shelton, Cyril Slatter, Ann Spokes Symonds, Martin Slade, Mrs Sloper, Ron Tombs, Stella Van Gucci, Mary Weedon. Also the Governors of St Ebbe's School, Jeremy's Postcards, the Centre for the Deaf and Hard of Hearing, Oxfordshire Photographic Archive, Oxford & County Newspapers, particularly Keith Price and John Chipperfield, and the Bodleian Library Oxford.

Particular thanks to James Steven Curl for permission to use photographs from *The Erosion of Oxford* published by Oxford Illustrated Press, 1977, to Cassell plc for permission to use photographs and quotations from *In West Oxford* by T Squires published by Mowbrays, 1928, to Robert Dugdale Publications and Edmund Gibbs for permission to quote from *Our Olive* by Olive Gibbs, published 1989, and to Mr Andy Panton, author of *Farewell St Ebbe's* , for his interest and help.

Occupation and Trade

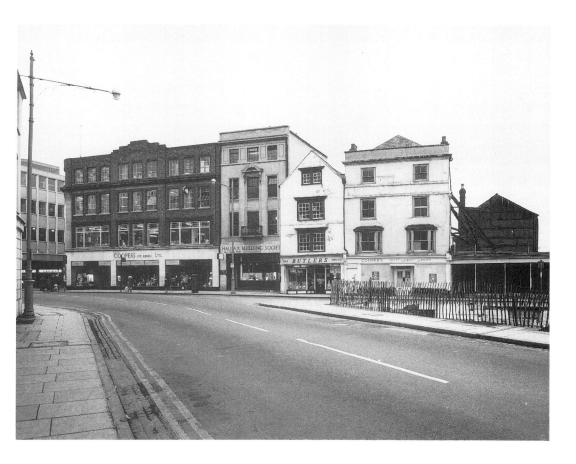

Macfisheries corner on the right, with St Ebbe's Street on extreme left. Macfisheries was a wet fish shop situated on the triangular piece of land between New Road, in the foreground, and Castle Street behind. It is well remembered for its blue tiles, marble slabs and, in particular, the small goldfish pond and fountain under the counter slabs.

The unusual shape of this corner was formed when New Road was built across the northern part of the Bailey of Oxford Castle in 1776.

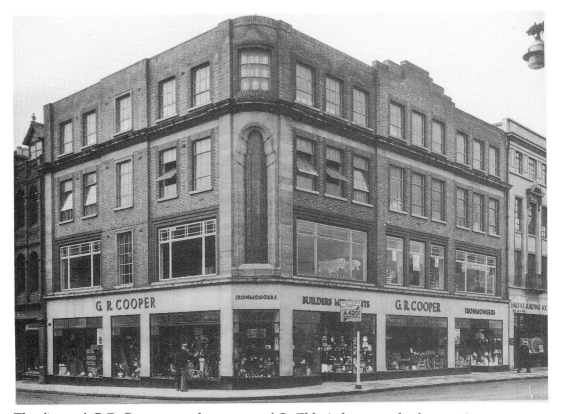

The firm of G R Cooper on the corner of St Ebbe's became the largest ironmongery store in Britain. Coopers was also known as The Original City Dustpan and it's emblem, a brass dustpan, hung outside the store for many years. In 1957 employee George Taylor, born 1900, recalled his early days with the firm. *When I joined in 1915 the shop opened 8.30 to 7.00 p.m., not closing for lunch. Early closing was Thursday when the shop closed at 1.00 p.m. Closing time was 8.00 p.m. on a Friday and 10.00 p.m. on Saturday. Every Friday, after closing time, the fixtures had to be filled in readiness for Saturday. This frequently meant working until 10.00 p.m. Time off in place of overtime worked, or overtime rates of pay were not recognised in the shop prior to the 1914—18 war, but once a year Mr Frank Cooper would give a day off to members of the staff (not of course all together on one day) and give them money to spend on this holiday.*

This family firm was started in 1875 by George Randall Cooper, the grandfather of the present managing director. St Ebbe's was, at that time, the busy shopping centre of Oxford. On the right-hand side of the road on the corner stood Tyler's, then Gibbs the sweetshop, Giles the paper shop, the Original City Dustpan, Arnotts Bakery, Nash & Walker butchers, and the British and Argentine butchers. A pawnbrokers was next *'where it was the practice to pawn one's suit on a Monday hoping to redeem it on Saturday if possible'*. On the opposite side of St Ebbe's was the Sherburn Arms on the corner, then Radbone the grocers, then Picketts the music shop, Eastmans butchers, then a penny bazaar, then Alden the grocers. Coopers gradually expanded, taking over smaller shops on both sides, including Arnotts Cake Shop in St Ebbe's and Herbert and Bolton's shop and Collier's garage in Castle Street.

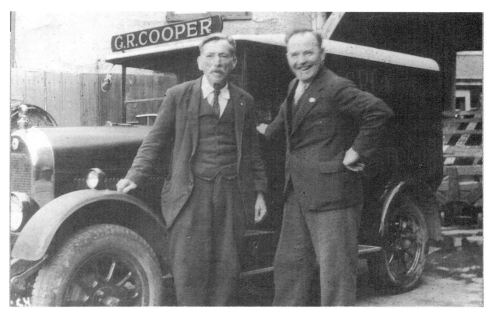

An early G R Cooper van, with Harry Neill of Mill Street, Osney, on the right. Harry became Manager of the Wholesale Department, known in later years as Multifactors. Coopers boasted that they would deliver anything 'cash on delivery'

A later van, for the delivery of Calor Gas.

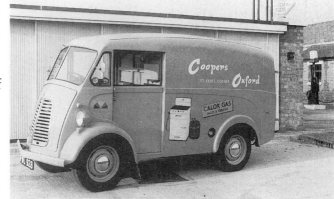

Coopers boasted a comprensive range of products, hence its name — The Original City Dustpan. Early products included wooden clogs, which were particularly popular with workers at the various breweries in the area, tin and iron kettles and saucepans, old fashioned ashpans, shoe and boot laces, fancy mats and lino, darning wools, needles and cotton, spectacles with steel or gilt frames. An interesting item was the Pharoh's basket. This was available in two sizes and made up in nests of three baskets. There was the large or small sizes bound or double bound. The baskets were oblong in shape with a lid which fitted over two loops. A piece of string was threaded through for carrying purposes. In 1915 the baskets retailed at 1s 4d or 2s 9d according to size. Large and small oil lamps, many of which were sold without glass or shades as night lights, gradually went out of fashion as gas lighting was introduced, but oil lamps were still being sold for use on carriages.

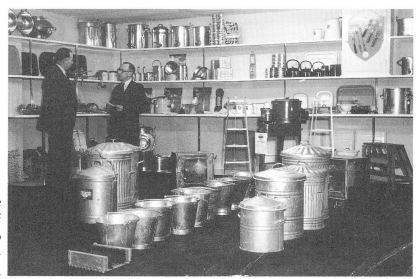

Coopers was the main stockist of canteen supplies to the City's municipal restaurants. This photograph is of the galvanised department in the early 1940s. Buddy Mapes on the left and Cyril Cartwright on the right. Cyril's sons were also employed by the firm; Ken for 51 years, Gordon for 49 years, and Clifford for about five years.

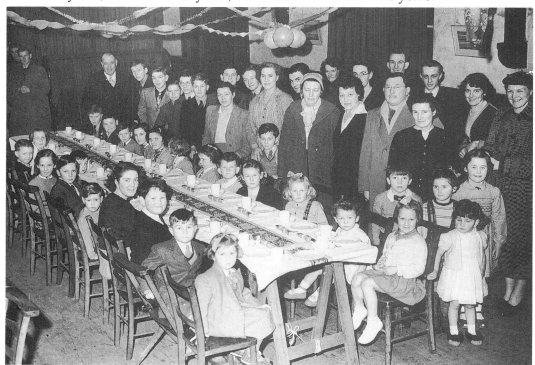

Coopers was always a family firm, and included a Sports and Social Club for its employees. This children's party of c1950, held in the St Aldates Church Rectory Rooms in Pembroke Street, includes June Simmonds, Bob Simmonds, Mrs Jennings, Arthur Pearce and Mr Edwards. The children include Mary Simmonds, Raymond Mutton, Alastair Cooper, Terry Pearce.

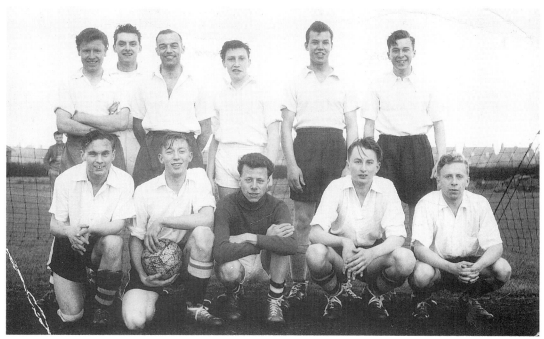

On 25 April 1957 the Coopers Apprentices Football Team, above in white shirts, played 'The Rest', below in striped shirts. Back row: Keith Templar, Tom Hicks, John Mutton, David Gilbey, Nigel Wilbur-Shepherd, Ian Bannister. Front row: Ted Walton, Gerald Washbrook, David Carter, Roger Cherry, Ian Kingdom.

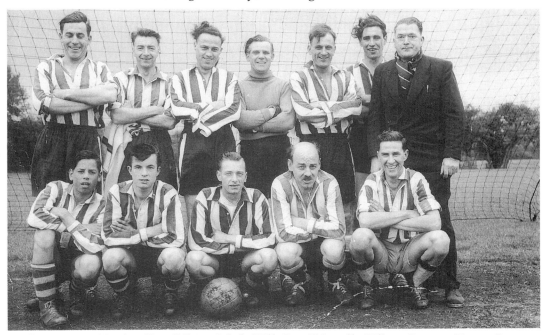

Back row: Rex Hanks, Ken White, Mick Hill, Reg Westall, Gilbert Bower, Terry Cooper, Arthur Ford. Front row: -, Gordon Mutton, Ken Cartwright, Bill Harris, Rodney McGuinness.

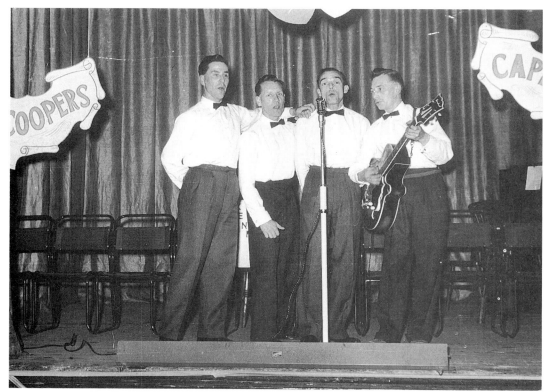

In 1959 several members of staff got together to present Coopers Capers, a social night for all employees. Left to right: Rodney McGuinness, Ray Venney, John Mutton, Ken Cartwright.

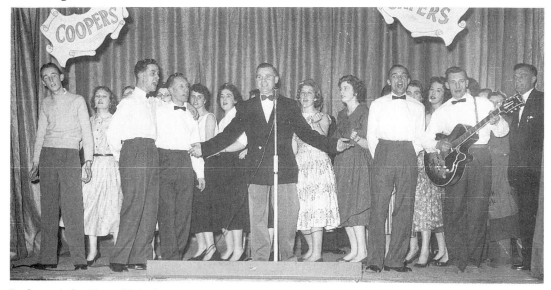

Left to right: Tony Hilsdon, Ranee Bellcourt, Rodney McGuinnes, Ray Venney, Sheila —, —, Reg Westall, Ann Washington, —, John Mutton, Joy Clements (hidden), Barbara —, Ken Cartwright, Gilbert Bower.

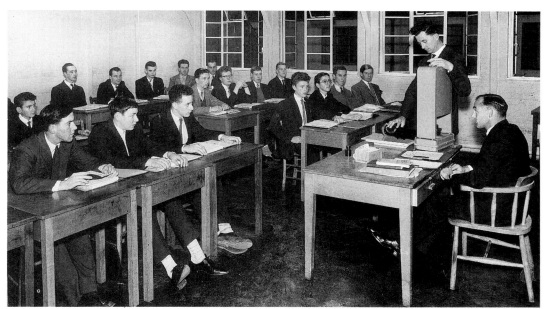

Intensive training was the norm with Coopers. John Mutton, seated, and Ray Parrott, standing, deliver a lecture at the further education annexe in the Cowley Road c1960 for the Oxford and District Ironmongers Assistants Association.

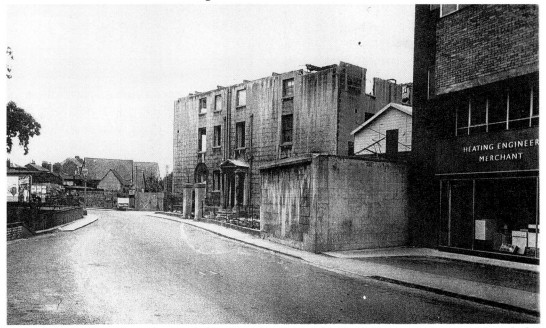

Coopers site was bought by Selfridges in 1966. The builders merchants side of the business moved to new premises in Paradise Street, seen here on the right hand side, next to Westgate House. This, an early 18th century building, was formerly the home of the owners of the brewery, later Hall's Oxford Brewery Limited, which was situated on Swan Island, the present site of Telephone House. A later tenant was Colonel Bradley, the owner of Weeke's bakery.

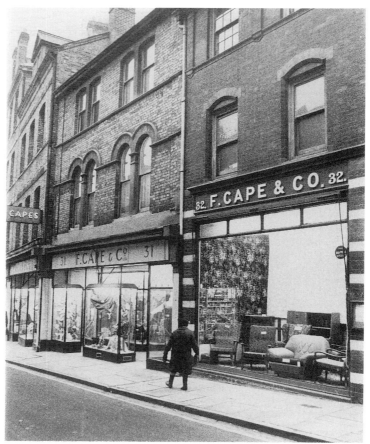

F Cape & Co Limited was founded by Faithful Cape in the early 1870s, originally at 26 St Ebbe's Street, in the part of St Ebbe's known as Cheapside. During the 1880s, Capes premises included 29 St Ebbe's and later Nos. 30 and 31 St Ebbe's, which at that time were two very dilapidated houses. Faithful Cape demolished these and built new shop premises. By 1892 the company had acquired premises at 47 Church Street and, in 1899, purchased 28 St Ebbe's. In 1900, No. 32 was added together with No. 9 on the other side of St Ebbe's Street, which became a wool shop. Also in 1900, Cape's opened its largest branch at 86–90 Cowley Road. By 1905, No. 11 and 12 St Ebbe's Street were purchased, thereafter forming Cape's menswear and shoe departments; Nos. 7 and 8 were eventually acquired to provide the furnishing department. By this time the company was in the hands of Henry Lewis, Faithful Cape having sold the business in 1890.

By 1907, Cape's employed 63 assistants at St Ebbe's, plus a complement of carpenters, domestic servants, messengers, porters, etc. Of this total number almost 40% lived in, the majority residing over the St Ebbe's Street store. The upper floors provided bedrooms, a dayroom with a piano and a dining room where all members of the staff, whether resident or not, could take dinner and tea each day. The live-ins were looked after by a housekeeper and maids, who also prepared daily meals for the entire staff. The practice of living-in was a common arrangement in drapery and grocery establishments throughout the country until the Second World War, but was declining in the inter-war years. Cape's discontinued the live-in system in the early 1930s.

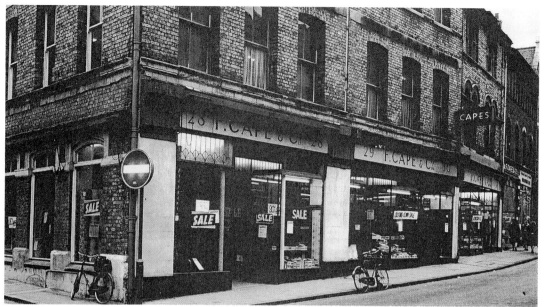

Cape's boasted that it stocked anything and everything. Regular Winter and Summer Sales were held, which were always very well attended. Its sales catalogue included clothing, furniture, crockery, luggage, stationery and toys and, in 1910, boasted 75 pairs of ladies' cycling knickers and 96 motor scarves, an indication of the increasing popularity of these means of transport.

The interior of Cape's. Cape's operated a cash railway throughout its department store, whereby any cash taken at the counter was placed by the assistant in a small metal container and shot by elastic catapult along a wire to the cash desk, and change returned in the same way. The cash railway was eventually replaced by a pneumatic tube system. On 5 February 1972 the store closed its doors for the last time, and, a few months later, a substantial part of the St Ebbe's premises had been demolished.

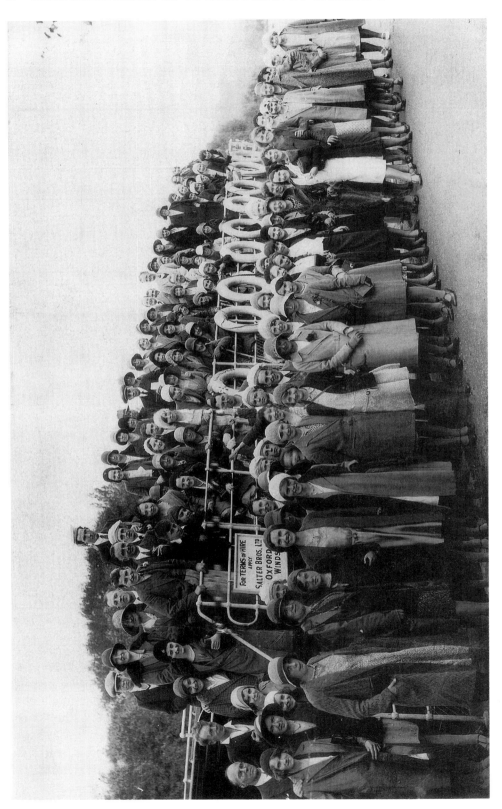

Cape's actively pursued a social policy for its employees, including sporting clubs, annual outings and stocktaking parties. This 1931 annual outing was a boat trip from Salters at Folly Bridge to Nuneham Courtenay.

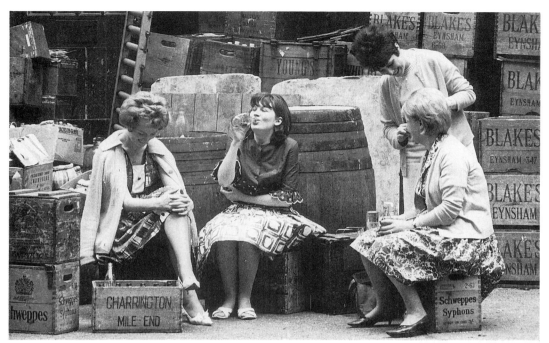

Also in St Ebbe's was the firm of G T Jones, Wine Merchants. Left to right: —, Chris —, Vera —, Rosemary Green seen here during a lunch break in 1964.

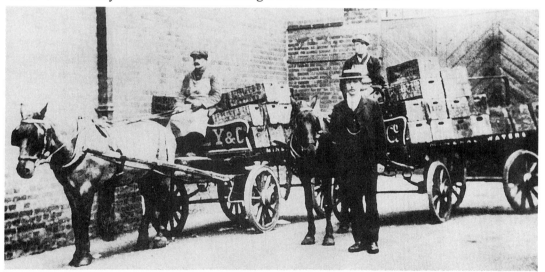

Beesley's Mineral Water factory was situated in Sadler Street, St Ebbe's, close to the gas works. It was George Beesley who, in 1904, was described as a beer retailer with a shop at 73 Cowley Road. Edward Beesley appeared about 1907 in Canal Street, Jericho and acquired the premises in Sadler Street around 1914. The firm operated from both Sadler Street and Canal Street until the mid-1920s, producing its well-known lemonade, ginger beer and other fizzy drinks, with Edward's brother, Fred, as factory manager. Edward lived at the Sadler Street premises with his unmarried sister, Clara, selling the business in the 1960s.

The Swan bakery in Paradise Street, seen here in 1962, provided occupation for many residents.

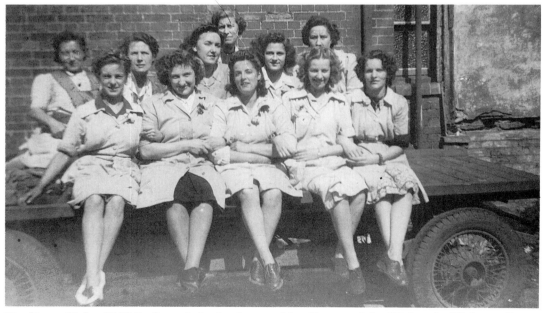

Starlings Girls c1943. Left to right, back row: Mrs Cooper, Mrs Richards, Violet −, Betty −, Kit −, Lydia Davis. Front row: Lily Dyer, Dorothy −, Eve Eeley, Vera Honey, Iris Harris. During the war, these girls were employed making blackout curtains for all the colleges and hospitals, also sewing together carpet strips.

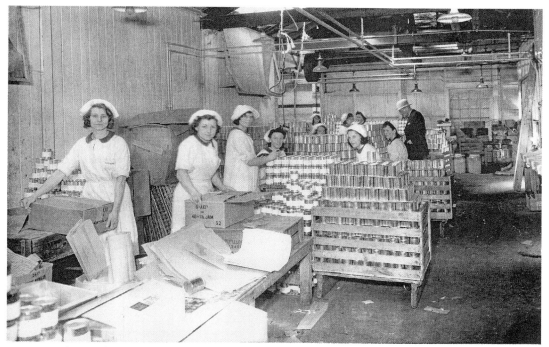

The packing department of Frank Cooper's Marmalade Factory in 1942.

Frank Cooper's famous marmalade first went on sale in 1874, developed by Frank's wife, Sarah Jane, from her mother's secret recipe. Sarah Jane made more than the family could consume, and the surplus was sold in the family delicatessen, known as the Italian Warehouse, at 43 High Street. Demand for the course-cut dark marmalade sold in earthen-ware jars grew, and became the mainstay of the business. New premises were established in Park End Street in 1902, and other products, such as horseradish sauce, mint jelly and fresh fruit preserves, were made. Frank died in 1927 and Sarah Jane in 1932, leaving five children to continue the business. By 1949 the Park End Street site had become too small and the business moved to the old Majestic cinema in Botley Road, on the site of what is now MFI. In 1964 the company was taken over by Brown and Polson, and production moved to Scotland.

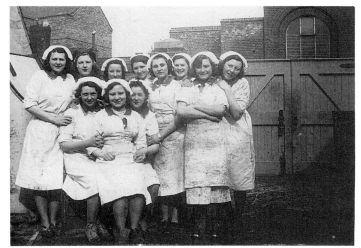

Marmalade Girls, as they were known, c1936, in the yard by the gate leading out into Hollybush Row. Doris Lindsey is sitting on the left, Majorie Stroudley is standing with her hand on Doris's shoulder, Kate Butlin is next to Marjorie, and Gladys Lord next to Kate. Pansy Stanton is on the far right.

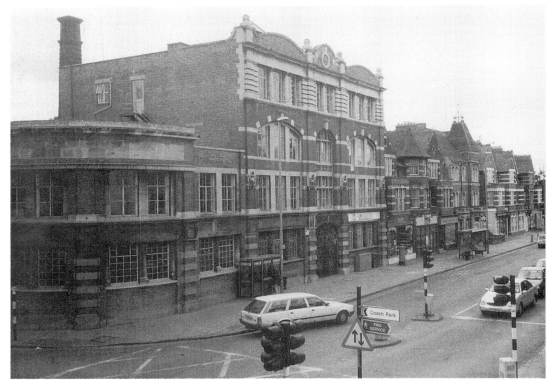

Frank Cooper's Marmalade Factory on the corner of Hollybush Row and Park End Street. During recent years, this was an Antiques Centre, but it is now vacant awaiting redevelopment.

The Post Office sorting offices in Beckett Street. These buildings are due to be vacated in January 1998 when the entire operation will move to new premises at Cowley.

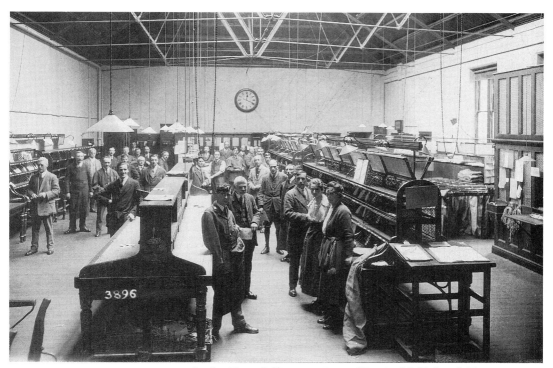

A rare view c1919 inside the Post Office sorting office in Hollybush Row.

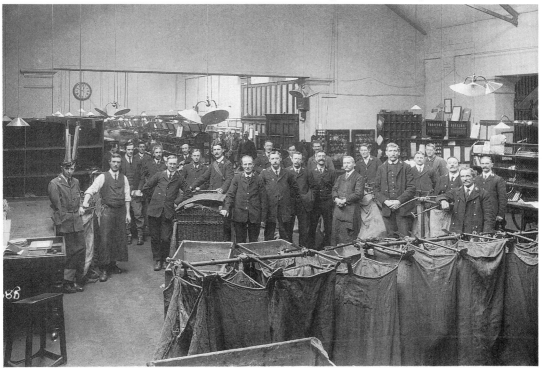

Another view of the same date. Mr Hubert George Crook is the one-armed man in the front on the left of the picture.

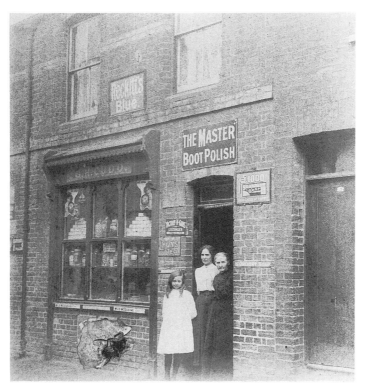

An early picture of the premises of G H Cudd, in St Thomas's High Street.

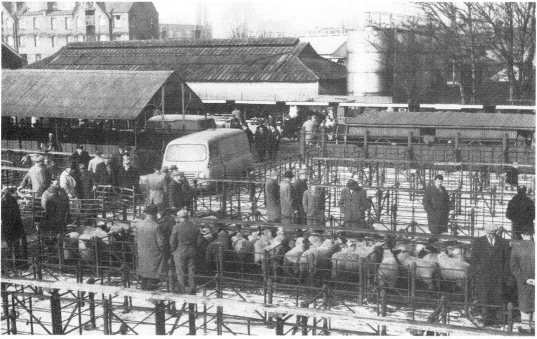

To avoid congestion from the sheep and cattle, Oxford's cattle market moved from Gloucester Green in the city centre to a site at Oxpens im St Thomas's, opening on 6 April 1932. This photograph was taken during the early 1950s and shows Old Christchurch Buildings at the top left.

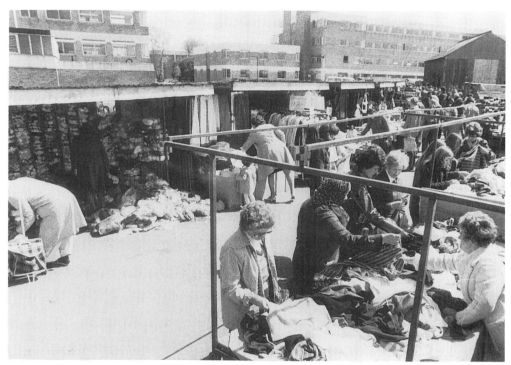

Wednesday was cattle market day, and regular crowds were attracted to its many colourful stalls. Gradually the market became surrounded by the modern buildings of the College of Further Education.

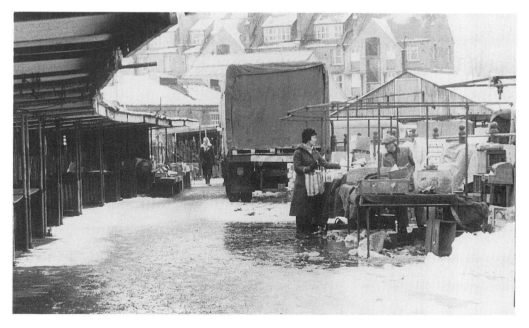

The market opened throughout the year, although trade was depleted during the winter months, as can be seen in this snowy scene. The last cattle market was held on 28 July 1982.

COMMERCIAL ROAD,

St. Ebbe's.
From 10 Littlegate street to
Gas street. Map D 7.

West side.
...... here is Friars st
1 Biles Fras. H. shopkpr
2 Lee Miss H
3
4 Paxton Andrew
6 Goodall Alfd. E. J
7 Edwards Arth
8 Carlo & Sons, caterers
... here is Blackfriars rd ..
... here are Gas st. ; Friars
 wharf & Speedwell st ...
East side.
16 Wheeler Mrs. E
17 Sherman Hy. Wm
18
19 Smith Jack
20 Stain Jn
21 Rowland Bryan H
22 Iles Mrs. M. I
23 Cooper Mrs. I. M
24 Miller Thos
25 Robinson Wm. funeral
 director
 New Centre for the Deaf
 & Hard of Hearing
 (Miss B. Hunt, sec.)
 (Oxford Diocesan
 Council) (lady worker,
 Miss D. M. Collcott).
 Tel. Oxford 43447

13A

Established
1813.

J. Hathaway, jun., and Son

LICENSED

HORSE SLAUGHTERERS

AND

Purveyors of Cats' and Dogs' Meat.

SUPPLIED FRESH DAILY.

30 Gas St., St. Ebbe's, OXFORD.

Best Prices given for Live and Dead Cattle,
fetched away on shortest notice.
HARNESS OIL and CART GREASE always on hand.

Extract from Kelly's Directory 1960 for Commercial Road (by permission of Reed Information Service).

Advertisement for J Hathaway, Horse Slaughterers, of St Ebbe's, c1890.

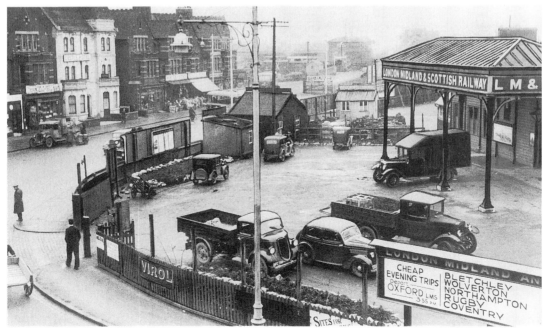

The railway provided occupation for many, particularly those residents from St Thomas's.

Pubs and Breweries

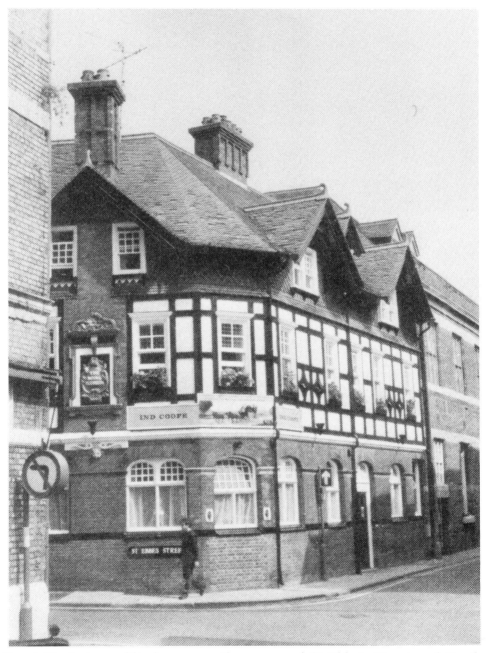

The Royal Blenheim public house, on the corner of St Ebbe's Street and Pembroke Street, was built in 1898. An ornamental cartouche is on the St Ebbe's Street wall. (*The Erosion of Oxford*)

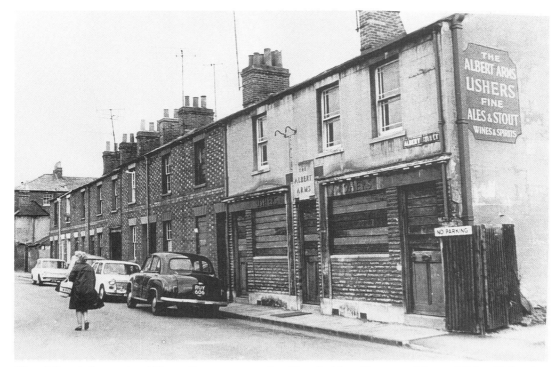

The Albert Arms in Albert Street, opposite Cambridge Terrace. Mr and Mrs Ephraim Knight, landlords during the 1950s and 1960s, kept a parrot named Billy, well remembered by many local children for its rather spicy language.

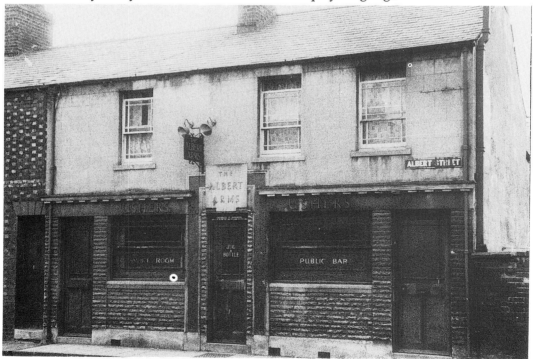

A view of the Albert Arms c1965.

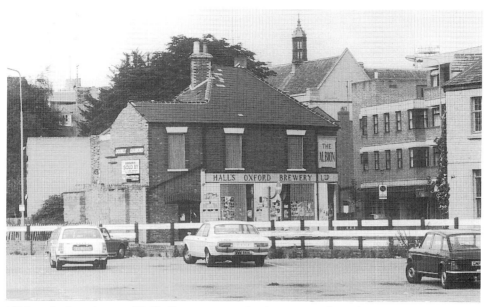

The Albion, belonging to Halls Brewery, at the junction of Littlegate Street with Albion Place and Friars Street. The Albion remained for a time after all around it had been demolished, finally being pulled down in 1980. A street sign for Friars Street was fixed to the wall of this pub and was rescued during demolition by a resident and now has pride of place in their garden.

During World War II, regulars at the Albion covered the mirror with coins, first dipping them in beer and then sticking them onto the glass. Left is Mrs Martin with Hilda Hookham on the right.

The Beehive was in Blackfriars Road. It was the closest pub to the Balliol Boys Club, and is fondly remembered by many members who recall that Mrs Godfrey, the landlady during the 1950s, allowed them to use the 'snug'. *'Of far more benefit to our minda and bodies were the recreational facilities of the Balliol Boys' Club in St Ebbes. Alas, as the name implied, it wasrestricted to biys only, but it catered in a way no other organisation did for the recreational and leisure needs of working-class boys and youths living in St Thomas' and St Ebbes.' Our Olive*

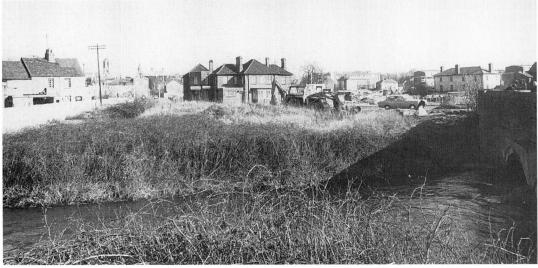

The Duke of York, seen here from Wellers Field across the Mill Stream during the 1960s.

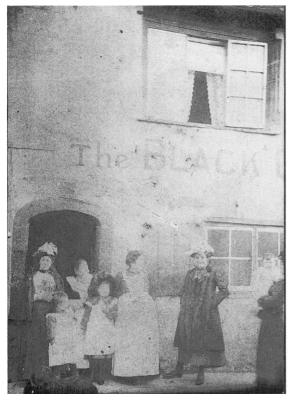

The Black Drummer at 3 Littlegate Street c1890. The ladies and children are members of the family of Robert Moger, landlord.

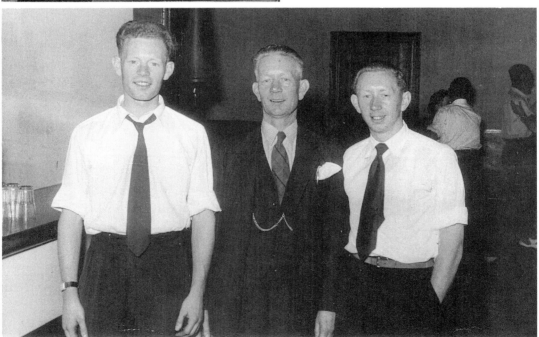

Frank Sloper on the left, later landlord of The Fountain and Prince of Wales in Jericho. Ted Sloper is in the centre, landlord of the Nags Head and the Duke of York. Denis Sloper on the right.

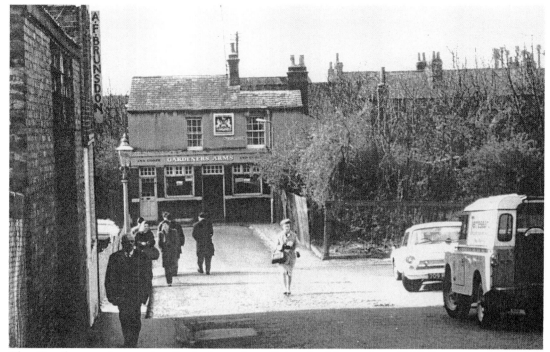

The Gardeners Arms shortly before demolition in November 1967. It was at one time kept by Ernest and Sue Eustace.

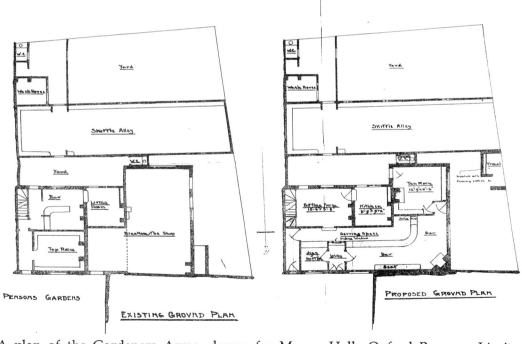

A plan of the Gardeners Arms, drawn for Messrs Halls Oxford Brewery Limited, showing the blacksmiths shop next door which was incorporated into the extended public house.

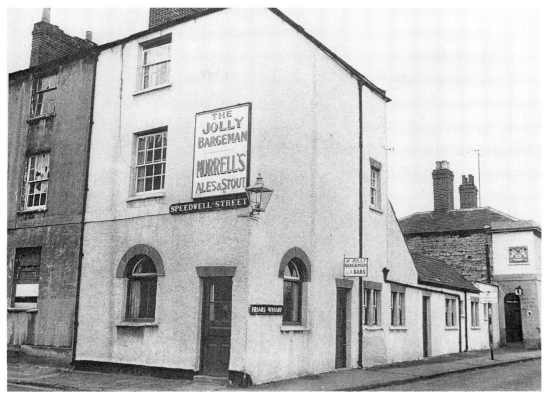

The Jolly Bargeman in Speedwell Street, on the corner of Friars Wharf, 1967. A one-time landlord was Chick Parker, an ex-professional footballer with Headington United, who coached the Balliol Boys football teams.

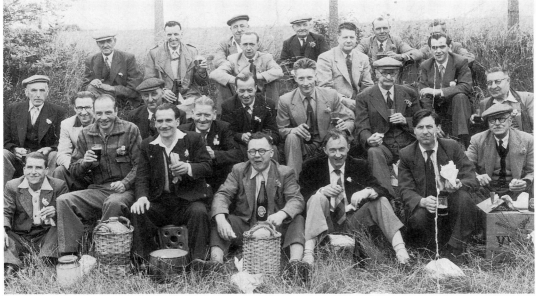

A trip to Ascot from the Jolly Bargeman during the 1950s. Group includes Ted Fisher, Arty Goodall, Harry Sherman and his son, Jock Goodall, Philip Jones, Mr Aris, Mr Huckstep, Mr Stone, Mr Phillips. The coach driver was Mr Norman Bradbury.

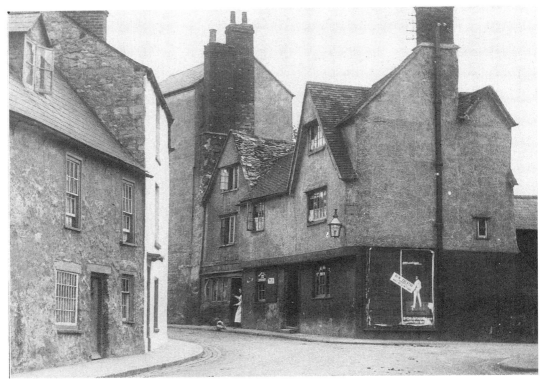

The Jolly Farmers in Paradise Street in 1908.

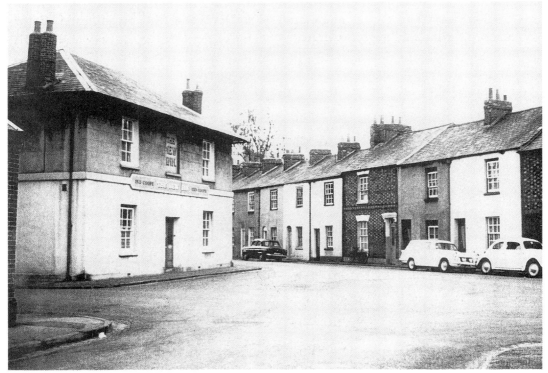

The New Inn, 1967, on the junction of New Street, Norfolk Street and Bridge Street.

A crowd in the Paviers Arms 25 May 1968, a Morland pub in Castle Street.

Ladies group in the Paviers Arms, Castle Street during the 1950s. Left to right: −, Mrs Bowers, Miss Gladys Bowers, −, May Hewlett(?), Mrs Dorothy Taggart.

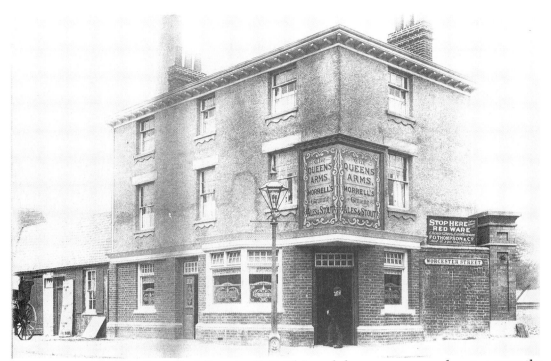

The Queens Arms in Park End Street, c1910. This pub has seen many changes over the years, and is now called Rosie O'Gradys. Park End Street was laid out c1770 to provide a new western exit from the city centre. In 1935 it was described as 'The Street of Wheels' because of the number of garages, including Eyles and Coxters, Hartwells, Kings Motors and Laytons.

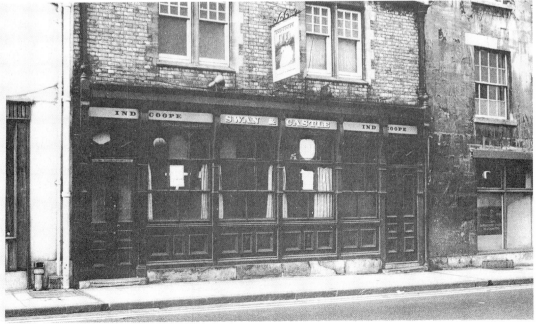

The Swan and Castle, an Ind Coope pub, in New Road 1968.

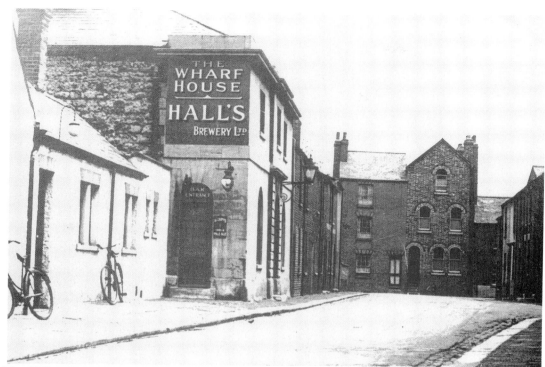

The Wharf House looking down Friars Wharf in 1959. The Wharf House was built c1830 alongside a busy wharf. River transport declined with the coming of the railway. The wharf was eventually filled in and the site developed for housing.

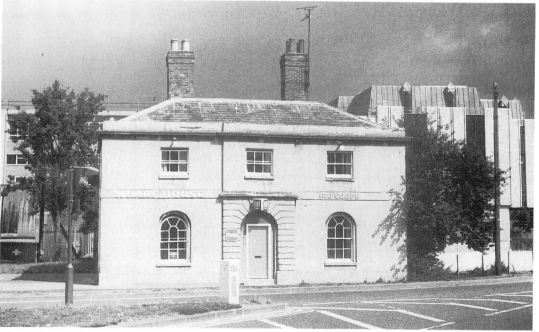

The Wharf House during the 1980s, standing in isolation and surrounded by new development and road systems.

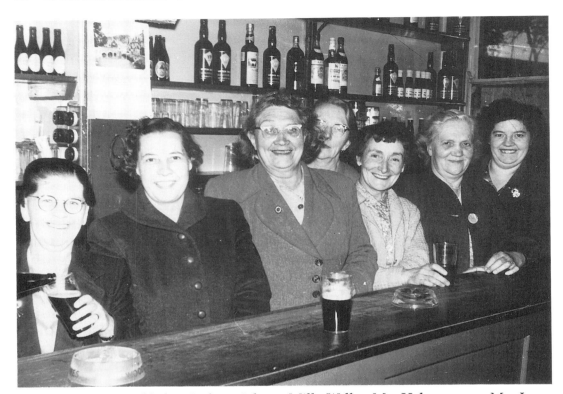

A convivial group of ladies. Left to right: –, Milly Weller, Mrs Holmes, –, –, Mrs Jones, Audrey Jones. The public house has not been identified.

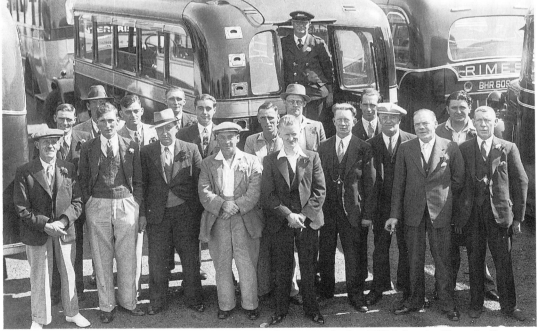

Outing from the Jolly Bargeman late 1940s. Group includes Bill Morris, Reggie Barrett, Harry Godfrey.

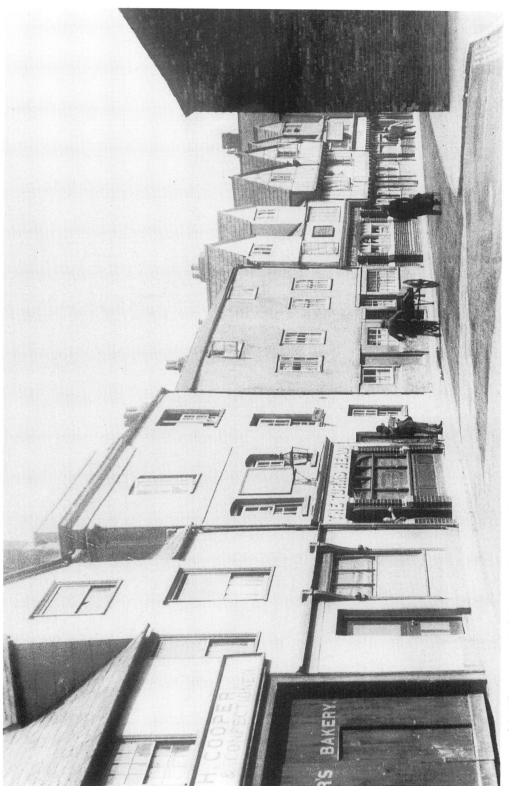

A view of St Thomas's High Street of c1910. The premises of G H Cooper, bakers, on the extreme left. The person standing in the doorway of The Turks Head is probably the landlord, Joseph Spencer.

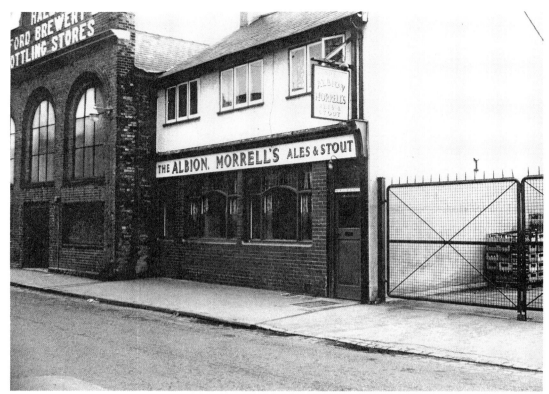

The Albion in Hollybush Row, a Morrell's pub next to Hall's Brewery bottling stores.

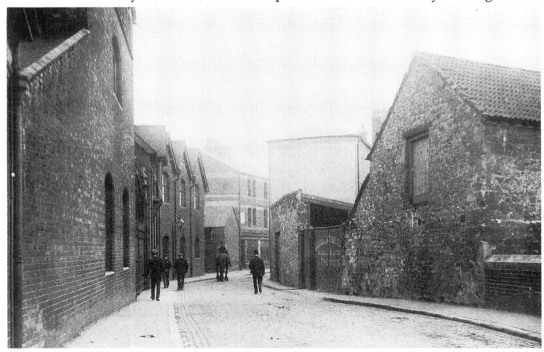

St Thomas's High Street 1913 with Morrells Brewery on the left. This part of High Street has changed very little over the years.

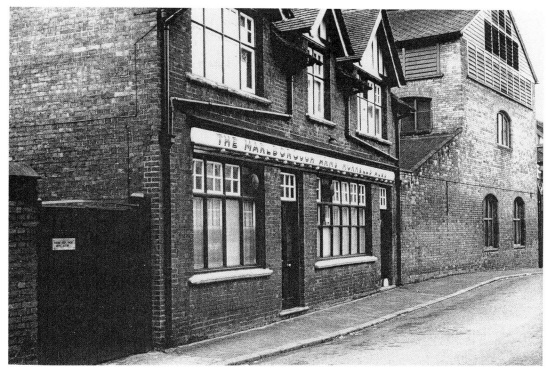

The Marlborough Arms in St Thomas's High Street, a Morrell's pub next to their brewery. This public house, formerly The Shoulder of Mutton, like many other public

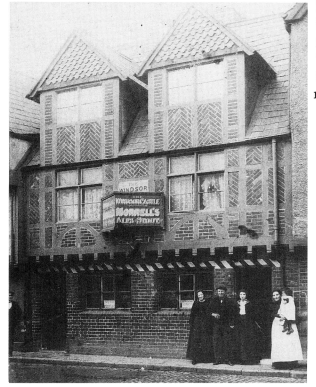

houses in the parish, offered lodging house accommodation to the many travellers who arrived in St Thomas's parish seeking work on the canal or the newly established railway.

The Windsor Castle in St Thomas's High Street, probably c1910.

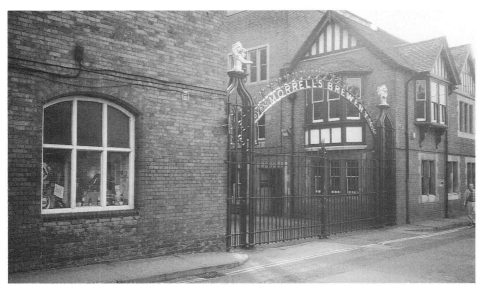

The gates at the entrance to Morrell's Lion Brewery. Morrells Brewery in St Thomas's is the oldest surviving family-run business in the City of Oxford. Brewing has existed in this parish for over 500 years. A brewing business was established by Richard Tawney and bequeathed in 1756 to his son, the future alderman Sir Richard, who left it in 1791 to his brother Edward, also an alderman and three times Mayor of Oxford. The elder Richard Tawney, a boatmaster, is first named as a brewer in 1743. In 1745 he was the tenant of a brewhouse and dwelling house on the present brewery site, which had been occupied since 1718 by the brewers Thomas and William Kenton, and then by William's widow Hannah until her remarriage. The business prospered and allowed him to provide for both his sons, Richard as a brewer and Edward as a miller and maltster with premises almost immediately next door at the Castle Mill.

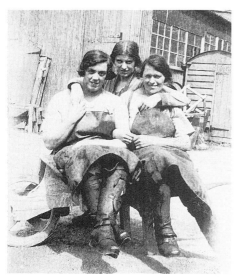
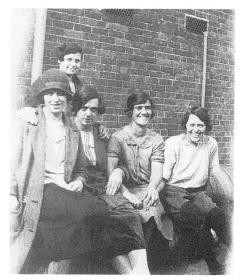

Morrells employees c1938, believed to include members of the Webb and Weller families, both extremely well-known names in St Thomas's.

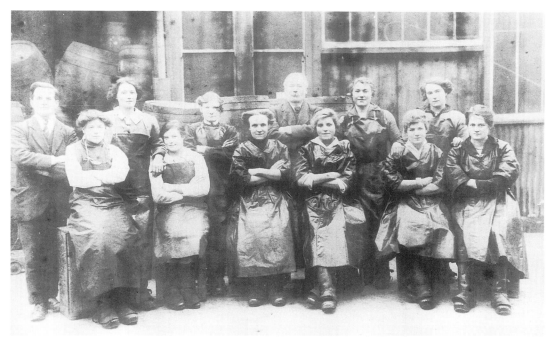

A wonderful early picture c1910 of Morrell's employees, note the clogs and leather skirts, necessary attire in the wet conditions of a brewery.

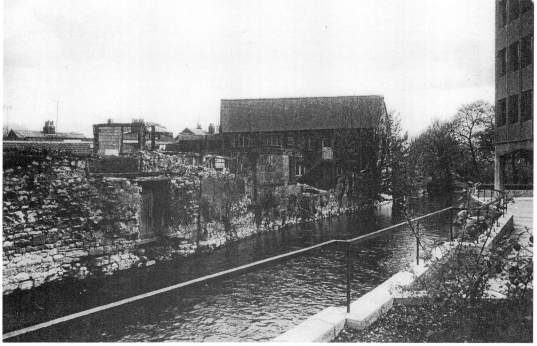

Lying on a spit of land, called Swan's Nest, the Swan Brewery, to the west of Paradise Street, was established about 1700 by Francis Loader. The brewery later became Hall's Brewery and was taken over by Allsopps in 1926. This photograph of Allsop's Yard was taken in 1969. Telephone House is on the right.

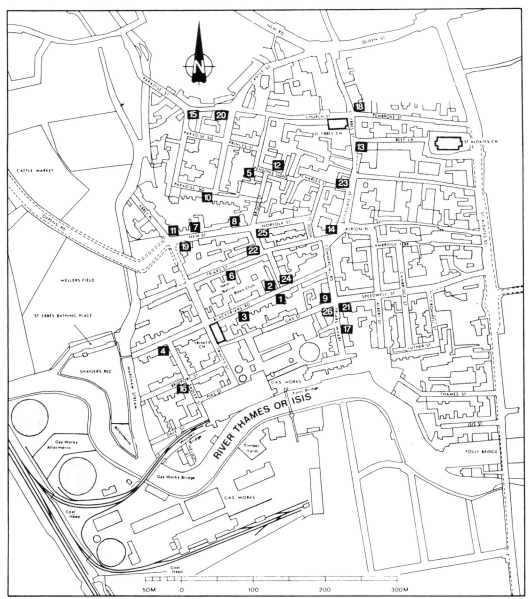

St Ebbes public houses. (1) The Ancient Briton, 97 Blackfriars Road; (2) The Beehive, Blackfriars Road; (3) The Game Cock, 84 Blackfriars Road; (4) The Masons Arms, 65 Blackfriars Road; (5) Gardeners Arms, Penson Gardens; (6) The Friar, 28 Friar Street; (7) Bakers Arms, 28 New Street; (8) The Bull, 46 New Street; (9) The Queens, Gas Street; (10) Prince of Wales, 14 Paradise Square; (11) The Royal Oak, 10 New Street; (12) Star of India, Penson Gardens; (13) Three Tuns, St Ebbes Street; (14) The Albion, Littlegate Street; (15) The Jolly Farmers, 20 Paradise Square; (16) Nags Head, 11 Bridport Street; (17) The Wharf House, Friars Wharf; (18) Royal Blenheim, St Ebbes Street; (19) Duke of York, New Street; (20) Paradise House, Paradise Street; (21) Jolly Bargeman, Friars Wharf; (22) Malt Shovel, Friars Street; (23) The Black Drummer, 3 Littlegate Street; (24) Foresters Arms, 13 Blackfriars Street; (25) New Inn; (26) Gas Works Social Club, Friars Wharf. Based on a map from *Farewell to St Ebbe's* , by kind permission of, and thanks to, Mr Andy Panton.

School Days

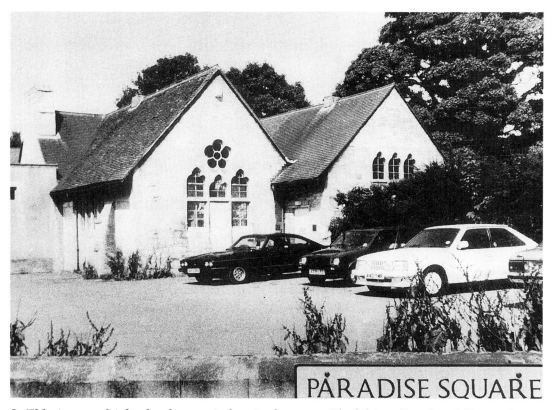

St Ebbe's parochial school occupied a site between Blackfriars Road and Friars Street. Following the formation of the new parish of Holy Trinity in 1845 these premises were divided; St Ebbe's retaining that part facing Friars Street as a boys school, and Holy Trinity, with access from Blackfriars Road, as a girls school. A new St Ebbe's girls school was eventually built in 1856 in Paradise Square. In 1871 an infant school was added to the girls' school in Paradise Square to accommodate 90 children, and a new boys' school for 170 pupils was built in Bridge Street. The old Friars Street site was handed over to Holy Trinity parish.

In 1910 the Paradise Square premises became an infant school for the whole area. In 1932 the building was modernised, a heating system installed and a new classroom built. The number of pupils, however, continued to fall until, by 1949, there were only 49 on the school roll. In 1927 Holy Trinity was transformed from a girls school to a junior mixed school, but finally closed in 1950 and the children transferred to St Ebbe's in Paradise Square, as a junior mixed and infant school.

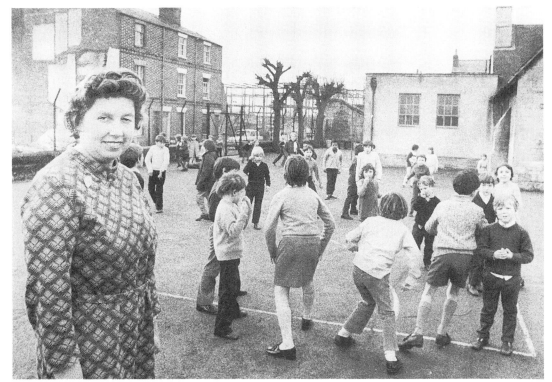

Rosemary Marshall, headteacher of St Ebbe's School, in the playground at Paradise Square. In the background the new College of Further Education is taking shape.

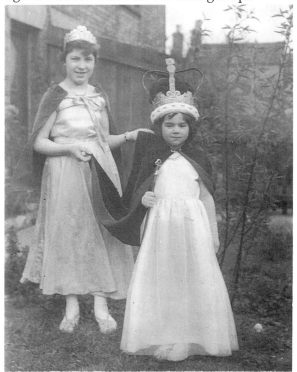

May Queen at St Ebbe's School. Rosemary Green on the left and Sheila Simms on the right.

Class II.
Wilfred Martin, Violet Izzard.
Frederick Lowe, Horace Willis,
Flora Amos, Lily Woodley,
James Smith, Laura Howrigan,
Frank Parsons, Evelyn Woodley,
George Haynes, Nellie Amos.

Class III.
Herbert Sanger, Donald McKenzie.
Ernest Kash, William Whiting,
Harry Davis, Reginald Prior,
Ethel Wheeler.

Class IV.
Cecil Hancock, Joseph Dolloway,
Winifred Amos, Violet Cross,
Ethel Brown, Pansy Parsons
 Diocesan Inspector of Schools:—
 Osborne M. Jones.
H Simpkin
Correspondent. June 13/12

Entry in St Ebbe's Infant School Log Book, May 24, 1912, following a visit by the Diocesan Inspector of Schools. The inspector recommended so many children for certificates, that the school had to apply to the managers for additional funds for their purchase.

Further Log Book entries record various events. Children commended in 1915 at St Ebbe's school were, Class IV Reginald Lowe, Joseph Brown, Edith Osman, Laurence Denton. Class III Thomas Brown, Winifred Ward, Albert Woodley, Aubrey Tustin, Jack Warnick, Winifred Couling. Class II Marjorie Godwin, Stanley Cross, Reginald Osman, Bertha Smith, Archibald Humphries, Eva Samworth, Colin Winter, Monica Wheatley. Class I Florence Whitlock, Violet Cross, Florence Walton, Stewart McKenzie, Frederick Trinder, Celia Norridge, Doris Eadle, Doris Day, Doris Hedges.

Holy Trinity School Log records in 1898 that *'Emily Boswell in Std IV demanded labour certificate and claimed her attendance last week. She was only twelve by my register, so I informed school board officer. He said her certificate of birth had been shown and she was thirteen, so her attendances were given by me and the girl marked as left in the register. Since, the register has been examined and it is proved she was only 12 and that the certificate had been tampered with. The girl returned to school on Wednesday.'*

Also at Holy Trinity, in 1927, Leslie Mildenhall, Eric Birmingham and Ronald Hook were caned on the hand for using bad language in the playground, and in 1928 it was recorded that *'one girl, Doris Faulkner, will not take the Scholarship. The parents are not willing for the girl to do homework.'*

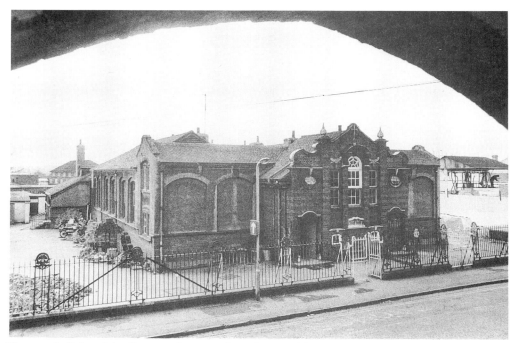

St Thomas's School in Oseney Lane, taken from Old Christchurch Buildings in 1975. At this time the school, which closed in 1971, was used by the College of Further Education as a building trades annex.

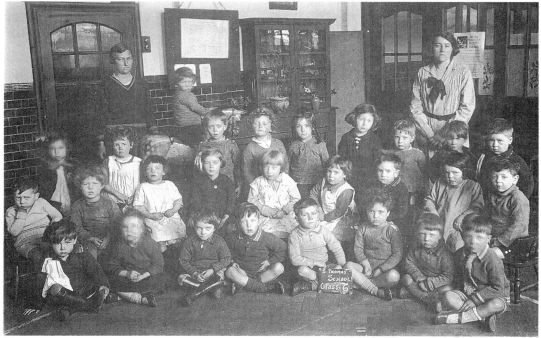

Class 6 of St Thomas's School c1927. Miss Elsie Clarke is the teacher on the right. Miss Clarke taught at St Thomas's school from 1926 to 1952. During the early years she taught the 'Backward Class', which took South Oxford children for remedial classes.

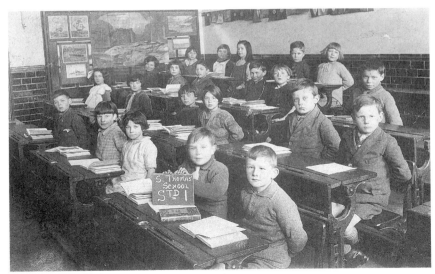

Standard I at St Thomas's School c1927. Note the children's arms behind their backs.

fitted for. If a little more liberty were given them, probably their efforts would bear more fruit. In his opinion, the curriculum wanted improving, but that was not a reflection on the masters and mistresses; it was the fault of the theorists in the Educational Offices in London. The tendency of the present age was to keep children at school longer than was the case in the past, and therefore it behoved them to work hard when they had the opportunity. He congratulated the prizewinners and hoped those who had been unsuccessful would be prompted to obtain one next year. He concluded by wishing the scholars a Happy Christmas and a Prosperous New Year.

Councillor Ray proposed a vote of thanks to the Sheriff which was seconded by Rev. Demant and heartily carried.

PRIZE WINNERS.

BOYS.

Class Prizes. Standard VII : J. Crumley and A. Bower.
Std. VI :- O. Horn, A. Simms, S. Evans and J. Blackwell.
Std. V :- G. Fielder, E. Simmonds, G. Taylor & A. Drewitt.
Std. IV :- A. Alder, H. Dale, S. Morgan and H. Goddard.
Std. III :- E. Barham, C. Harris, R. Middleton and E. Mitchell.
Std. II :- J. Hodgson, G. Cox, L. Ash, J. Blackwell.
Std. I : B. Alder, J. Claridge, R. Drewitt, B. Watson.

GIRLS.

Standard 7. D. Wilks, E. Jones. R. Cox.
Std. VI. G. Howse, B. Martin, M. King. and M. Brown.
Std. V. N. Martin, M. Peedle, G. Grimshaw.
Std. IV. D. Longshore, P. Fitchett, Holloway.
Std. III. D. Halfacre, G. Evans, B. Drewitt.
Std. II. L. Spencer, E. Mankelow, R. Stevens and S. Renie.
Std. I. J. Darby, M. Worrell, N. Perks.

The above prizes in both cases (boys & girls) were awarded for general progress throughout the year, and the children who obtained highest marks during the year.

SWIMMING CERTIFICATES.

GIRLS: O. Kersey, G. Bastle, M. Peedle, G. Howse, and R. Hayes.

BOYS :- A. Bower, J. Allday, R. Cousins, G. Crumley, W. Dale, A. Drewitt, S. Evans, G. Grant, O. Horn, A. Morgan, R. Noth, G. Seward.

SPORTS REPRESENTATIVES.

GIRLS :- E. Jones, D. Wilks, R. Cox, M. Cousins, G. Harris, G. Howse, M. King, M. Claridge, E. Grimshaw, N. Martin, W. Simmonds, J. Allsworth, D. Spackman, D. Longshore, N. Longshore, P. Kilbee, and J. Spencer.

BOYS :- J. Crumley, E. Buckland, S. Evans, E. Barham, E. Fielder, C. Hathaway, C. Harris, P. Allen, G. Crumley, L. Ash,

A page from *The Gazette,* Easter Term 1923, the school magazine of St Thomas's School. This small magazine was edited by the children and was often handwritten. These pages record the Prize Winners, and successes in swimming and sports.

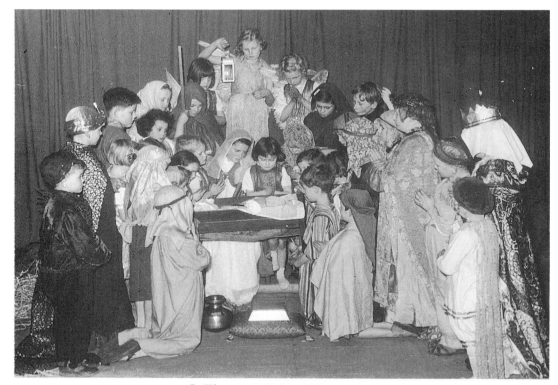

St Thomas's School Play 1952.

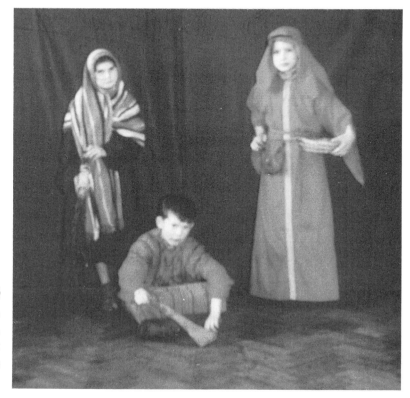

A nativity play of 1960 at St Thomas's School. Pauline Green, Alan Preston and Derek Shelton as the Three Shepherds.

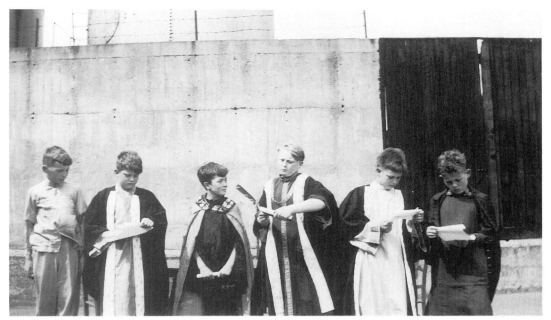

St Thomas's school play, The Pied Piper of Hamlin, c1955. Left to right: Peter Bowles, Paul Ashmall, Stuart Bushnell, Douglas Bartlett, Richard Claridge, Martin Minty.

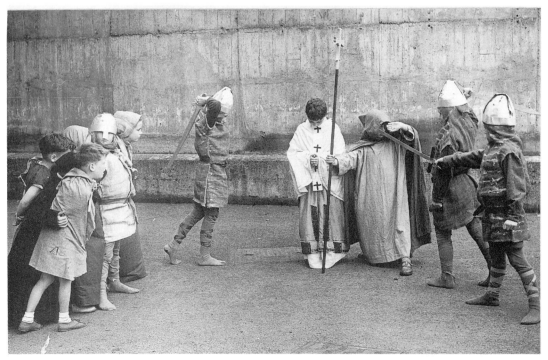

St Thomas's playground 1953. The group includes Ann Batty, Peter Bowles, and Paul Ashmall.

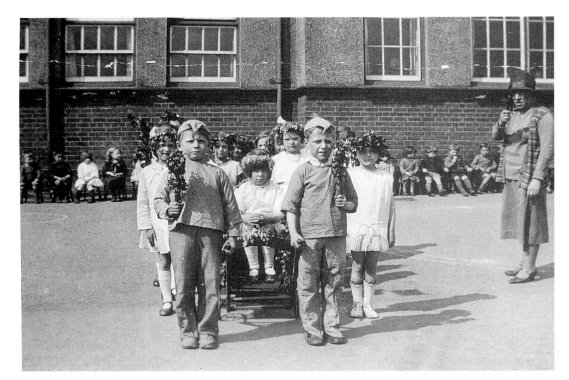

A May Day parade in St Thomas's school playground, under the watchful eye of the Infants' School headmistress, Miss Haithwaite, c1925.

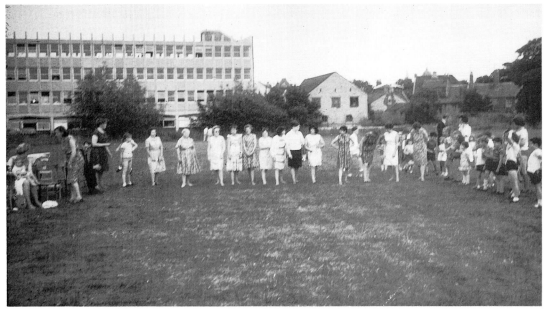

Mothers' race at school sports day, on St Thomas's Recreation Ground. Telephone House is on the left and the smaller white building is Stephen Reiss Club House, set up by ex-members of Balliol Boys Club.

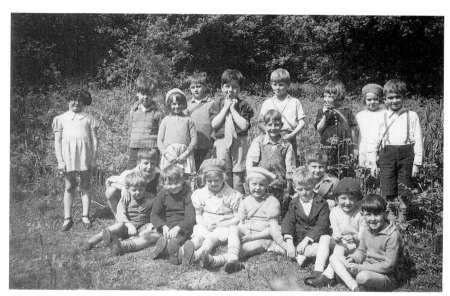

Class III St Thomas's school in May 1939 at Wytham Open Air Summer School. Group includes Dulcie Gray, Audrey Carpenter(?), John Gray, Joyce –, Olive Ilsley, John Oliver, – Quartermain, Emrys Lewis.

During the 1930s, Colonel ffennell of Wytham allowed Oxford Schools to make use of the Hill End Camp, part of the Wytham Estate. This was known as the Open Air School, and was very much enjoyed by all children. *Classes I, II and III visited Wytham School daily for the week – dinners being provided at 4d per head single, 3d each for 2 or more in one family. Green Dragon, Willow and Blue Bird classrooms in use.* Holy Trinity School Log Book June 9th, 1939.

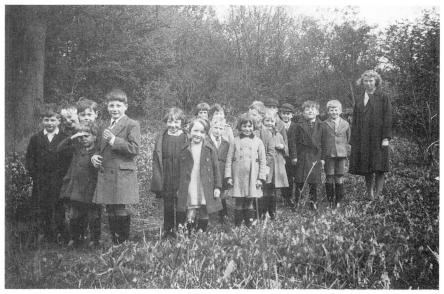

Walking amongst the bluebells. Group includes John Gray, Eileen Shepherd, – Quartermain, Olive Ilsley.

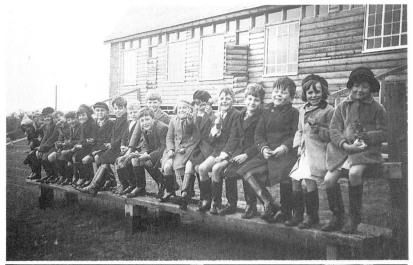

Resting on the stile next to the huts.

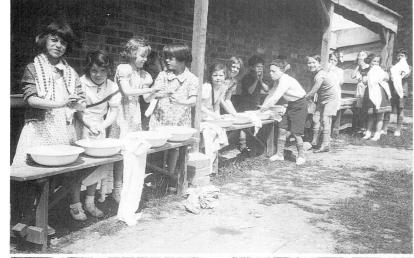

Washing up after dinner.

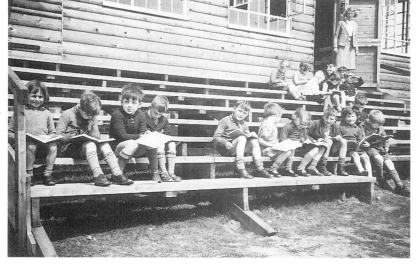

Reading in the sunshine.

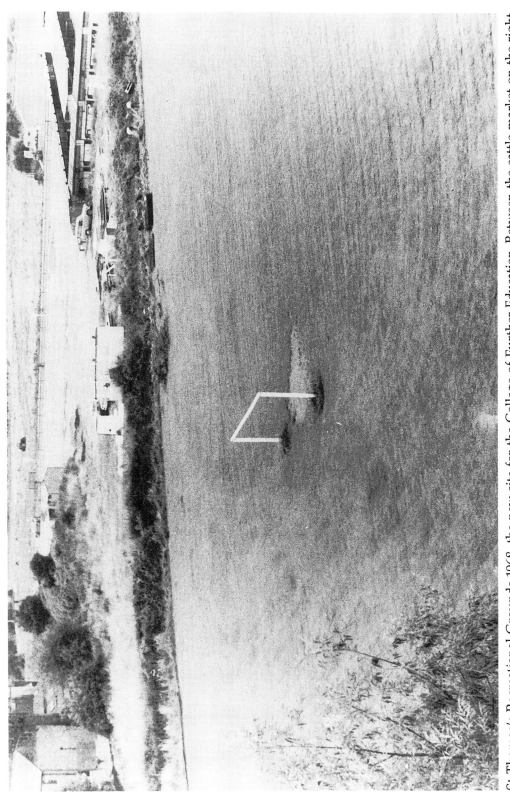

St Thomas's Recreational Grounds 1968, the new site for the College of Further Education. Between the cattle market on the right and the factory chimneys on the left can be seen the former Oxpens Lorry and Car Park.

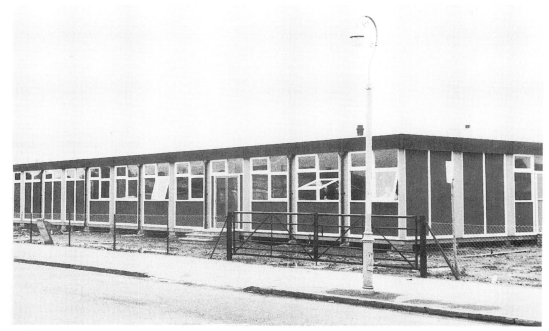

College of Further Education secretarial pre-fabs in Oxpens Road 1968. These were on the site of St Thomas's Recreational Grounds.

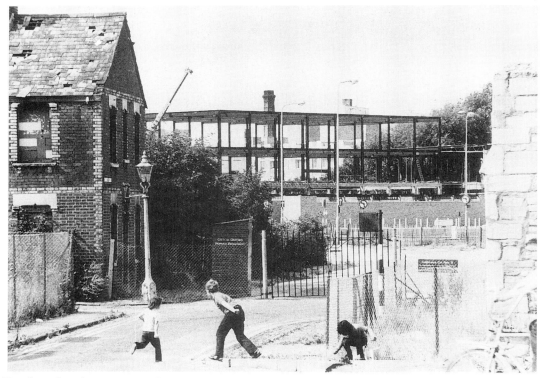

Further development took place in 1972. These children are playing in the ruins of the old houses whilst the college buildings take shape behind.

Events and People

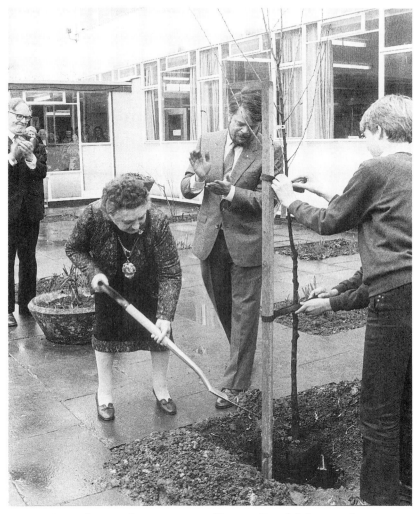

Olive Gibbs, née Cox, during her term in office as Lord Mayor, planting a tree in the grounds of the College of Further Education in Oxpens Road.

Olive Francis Cox was born in St Thomas's parish on 17 February 1918, in Old Christ Church Buildings. She won a scholarship to the Girls' High School in March 1929 but her father elected for her to attend Milham Ford School, commenting *'She will get just as good an education at Milham Ford as she would at the High School; the only difference is that the High School would try to make a lady out of her and that just isn't possible.'* Olive married Edmund Gibbs on 14 September 1940 and, through him, became involved in local politics. Elected to the City Council in 1953, Olive gained the freedom of the City in 1982.

Olive Gibbs, 1965, Sheriff of Oxford.

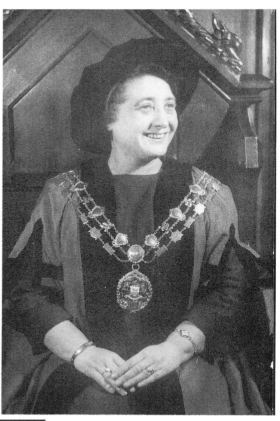

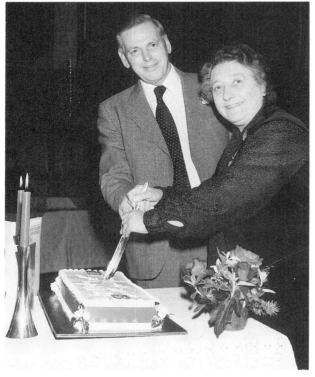

Olive and Edmund Gibbs in 1980 celebrating their 40th wedding anniversary at the Town Hall, to which many St Thomas's residents were invited.

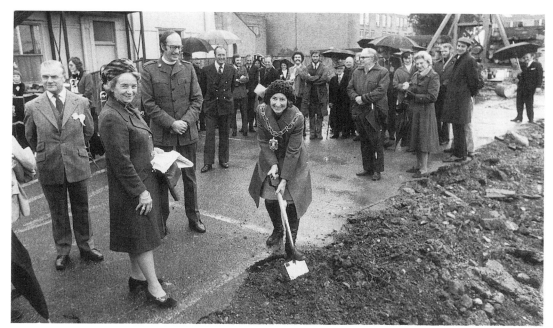

Councillor Ann Spokes, Lord Mayor, digging the first sod on the site of the Church Army Hostel in St Ebbe's, 1976. Baroness Faithfull on the left.

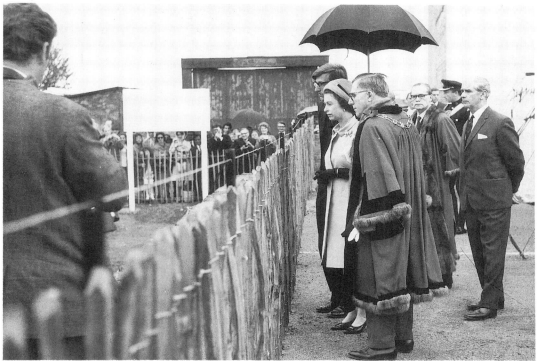

The Queen visiting St Ebbe's in 1968, inspecting the site of the excavations in Church Street. Left to right: Tom Hassell, H M The Queen, Councillor Frank Pickstock Lord Mayor. Behind: Councillor Peter Spokes chairman of the Planning Committee, Douglas Murray.

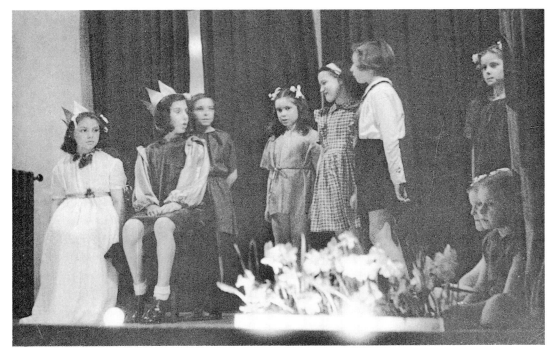

Young Women's Christian Association (YWCA) Christmas Show c1947 held in Church Street, St Ebbe's. Audrey Batts, Margaret Green and Audrey Allen are the Three Kings.

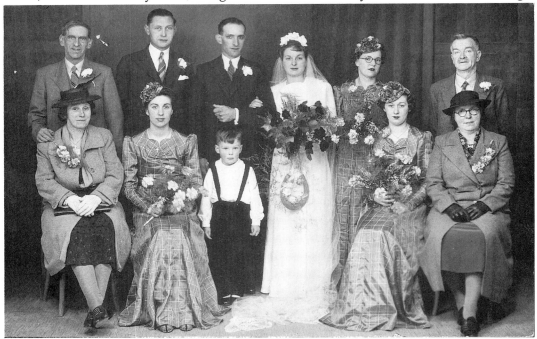

Wedding of Wally Weller and Rene Faulkner on 6 April 1942 at St Thomas's Church. Left to right, back row: Mark Weller, Sid Weller, Wally Weller, Rene Faulkner, Stella Faulkner, Alfred Faulkner. Front row: Alice Weller, Eileen Weller, John Blackford, Amy Morgan, Gert Faulkner.

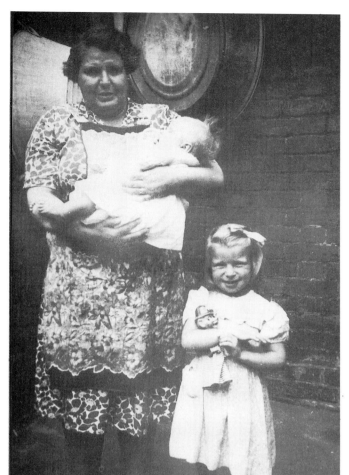

Mrs Percy Axford, with baby and young Lorraine Axford, outside her home in Friars Wharf c1954. Note the tin bath hanging on the back of the door.

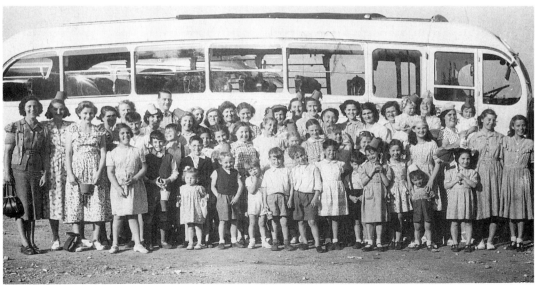

An outing to the seaside in 1951 with a group from Paradise Square area.

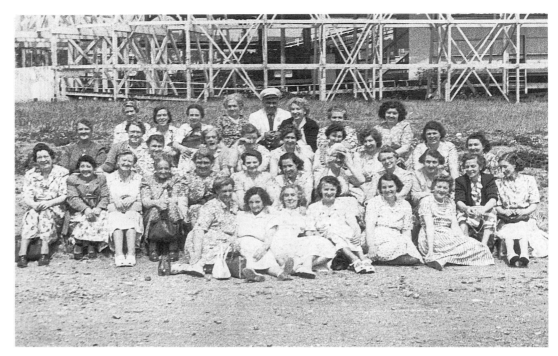

A women's group outing from the Friars to Southend c1950. Group includes Joan Mayell, Mrs Simpson, Audrey Jones, Sarah Jones, Mrs Waterman, Mrs 'Molly' Elsie Holmes, Mrs Weller.

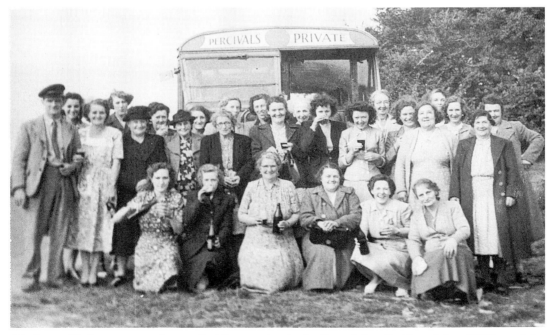

Mothers Union group from St Thomas's, including Mrs Sadler, Mrs Wilkes, Mrs Drewette, Mrs Cherry, Mrs Oliver, Mrs Newman, Marg Ashfield.

A church outing from St Thomas's, 1940s. Left to right: Mrs Win Rowlands, Mrs Mary Cox (mother of Olive Gibbs Lord Mayor of Oxford), Edna Webb at the back, Mrs Wilkes, Florence Darby.

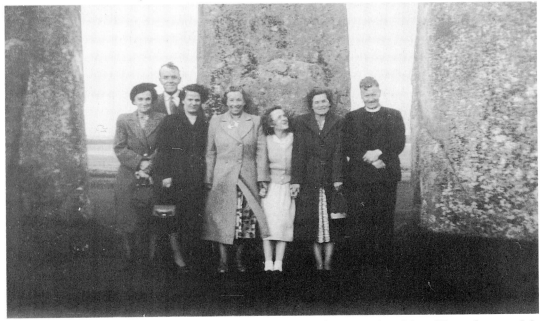

A church outing to Stonehenge early 1950s. Left to right: Mrs Humphreys, Mr Humphreys, – Bushnell, –, Rosemary Bushnell, Mrs Bushnell, Rev John Lucas.

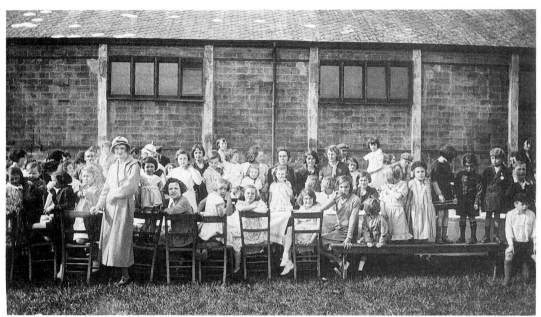

Silver Jubilee celebrations, 1935, in the grounds of St Thomas's 'Rec'. The building, a former stable, became part of Weekes' bakery. *'Next to the 'rec' were stables and a riding school. . . the dear prince (the Prince of Wales, later Edward VIII) often came there to ride when he was an undergraduate.' Our Olive*

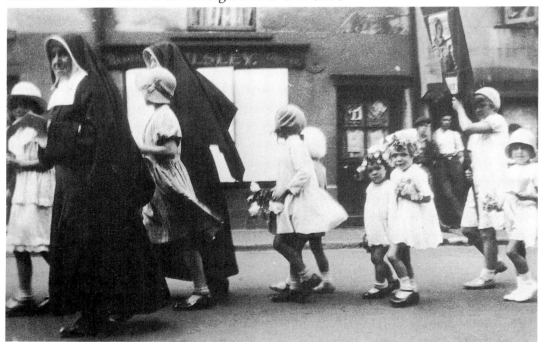

A parade around St Thomas's parish, 7 July 1935. Sister Ruth on the left with Sister Lilian on the right, Stella Faulkner is carrying the banner, Eileen and Barbara Cox are the very small children with flowers in their hair.

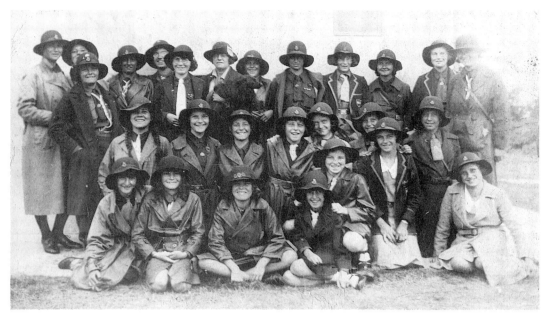

Girl Guides in 1935. Miss Holford was the guide leader and is the small person in the centre at the back of this group. Miss Pledge was the Assistant. This group includes Lucy Cox, Muriel Smith, Dorothy Taggart, Nellie Cousins, Margaret Sallis, Joyce Day. The group met in premises in St Ebbe's School in Bridge Street.

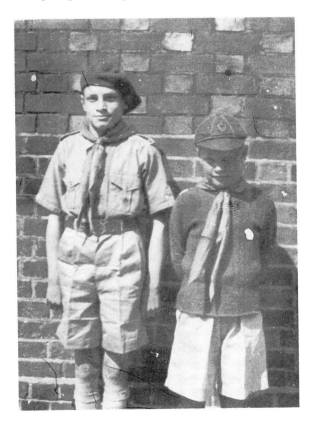

Douglas Brown on the left and Tom Brown on the right, taken c1950 at 59 Blackfriars Road.

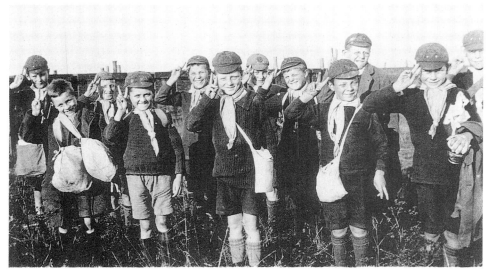

Scouts at Shotover Camp c1924. The IVth Oxford Troop had its original headquarters in Beef Lane, later moving to more spacious premises at Osney. *'It was in October 1908 that several boys living in South Oxford, who had long meditated upon a speech delivered there some months before by the Chief Scout, started a Patrol of six boys. The Troop necessarily remained small since only boys over the age of fourteen were allowed to join its ranks. By September 1910 the Troop numbered nearly sixty Scouts.'* Scout Headquarters Gazette, May 1911.

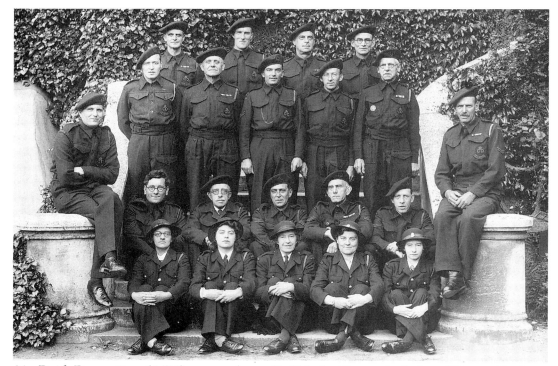

Air Raid Precaution (ARP) group from St Ebbe's. Group includes, Winter, Beckett, Trafford, Albert Hookham.

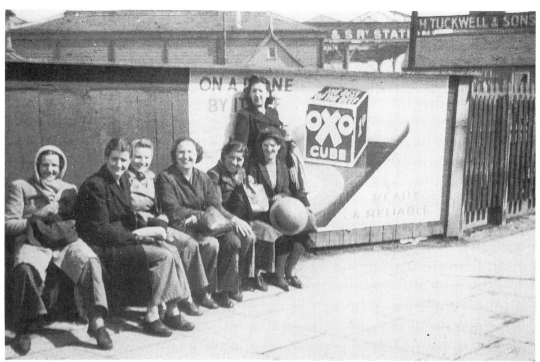

During World War II, many women were employed at the Pressed Steel factory on munition work. Here is a group of local ladies waiting for a bus near the railway station.

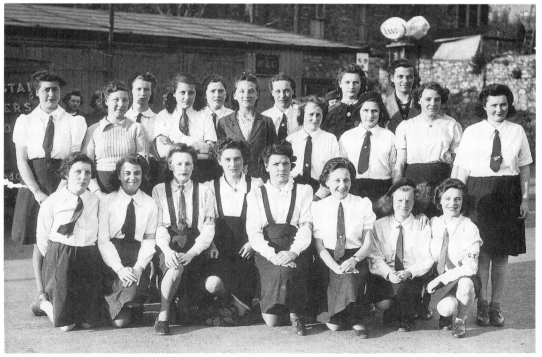

The Girls Training Corp (GTC) prepared local girls for training before they joined the Forces. Lily Dyer is on the right in the front, seen here in Circus Yard, St Ebbe's.

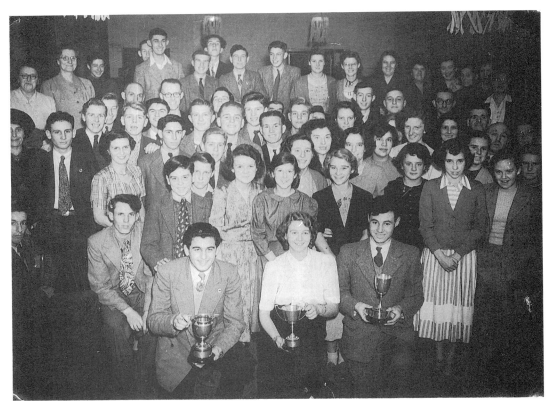

Audrey Winchester, chairman of Holy Trinity Girls Club, at the front, holding the Cup awarded by the Oxford Mail for the Best All Round Girls Club. The club had been founded by a group of ladies from North Oxford, to benefit the girls of St Ebbe's. The other two clubs in this picture are Bullingdon Boys and St Barnabus Mixed, and was taken in the Parochial Hall in Friars Street in the late 1940s. Group includes Betty Simpson, Greta Payne, Melva Smith, Pat Palmer, Mr and Mrs Winchester, Mrs Simpson, Mrs Payne, Marjorie Jacobs, Beryl Jacobs, Enid Jacobs, Margaret Simpson, Joyce Standen.

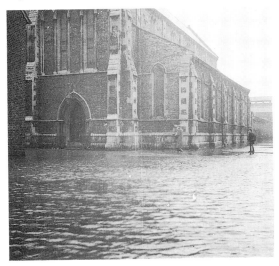

Holy Trinity Church during the floods of 1947. The man and the boy are walking on planks across the flooded road. *'In 1947 it snowed from the beginning of February until the end of March and when the snow melted most of the old parts of Oxford were flooded. The Mayor, Edgar Smewin, a railwayman living in St Barnabas, and Oxford's first Labour Mayor, set up a disaster fund.' Our Olive*

Members of Holy Trinity choir early 1950s. Left to right, back row: Beryl Jacobs, Betty Simpson. Front row: Marjorie Jacobs, Audrey Winchester, Jean Reynolds.

Holy Trinity Girls Club drama group in the vicarage garden. The play was 'Apple Pie Order'. Left to right, back row: Beryl Jacobs, Audrey Winchester, Lois Shirley, Marjorie Jacobs, Romana Jackson. Front row: Betty Simpson, Jean Reynolds, Paula Jackson.

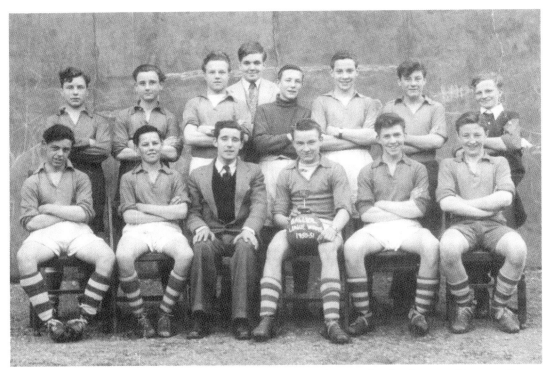

Balliol Boys Club football team 1950–51 season. Left to right, back row: George Carter, Maurice Legge, Billy Crisp, –, Clive Walker, Roy Waine, –, 'Willie' Williams. Front row: Ray Morse, Les Smith, –, Rex Jackson, Trevor Hookham, –.

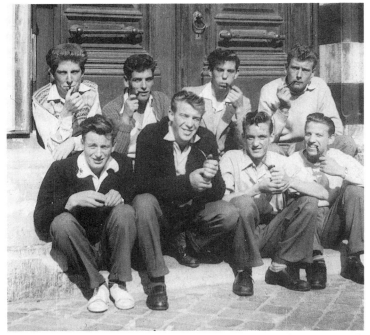

Balliol Boys in Belgium c1956. Left to right, back row: Mick Watson, Roger Cullwick, Malcolm Routledge, Ron Tombs. Front row: Pete Cooper, Bob Spokes, –, – Routledge.

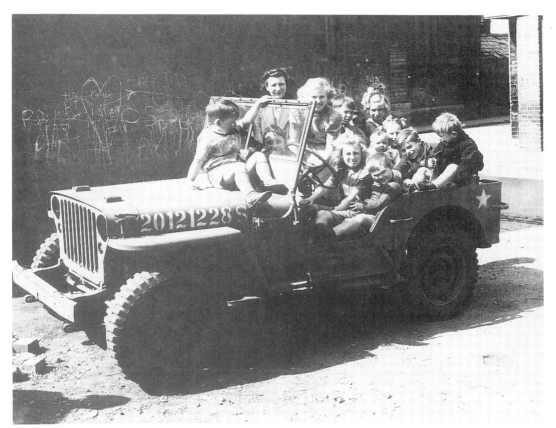

Friars Street c1943 and a GI jeep provides amusement for a group of children, including Mick Surrage, Sylvia Lambourne, Gwen Champion, Charlie Manning, John Manning and John Cairns.

Outside 105 Friars Street c1950. Left to right: Charlie Manning, John Cairns, Leslie Manning.

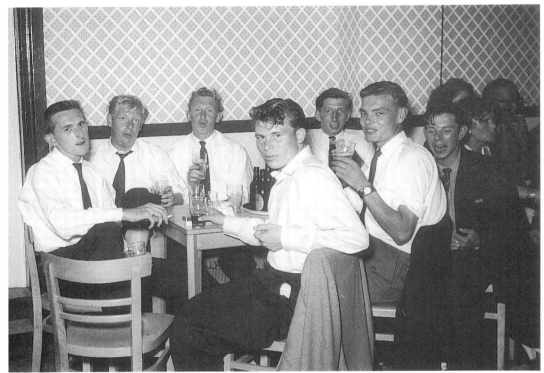

An outing of Friars people c1958. Left to right: Peter Hathaway, Mick Allsworth, Eric Manning, John Manning, others unknown. John Manning, at the front, was a boxer for Balliol Boys Club.

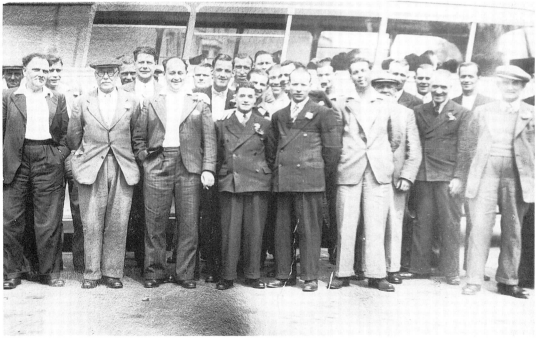

An outing, believed to be from the Jolly Bargeman, late 1940s.

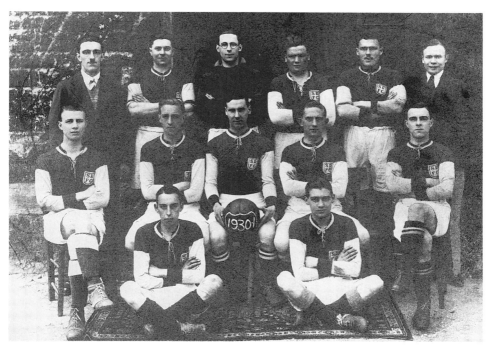

The Stephen Reiss Football Club 1930. Left to right, back row: Mr Godfrey, –, Alf Mold, – Woodward, Horace Webb. Middle row: Alf Alder, –, – Stimpson, – Neile, Harold Faulkner. Front row: – Allen, –. The Stephen Reiss Club was set up for ex-members of the Balliol Boys Club, and met in a building near to Weekes factory on the edge of St Thomas's Recreation Ground.

'Dusty' Webb with his prize winning greyhounds in St Thomas's Recreation Ground. The Webbs lived in The Hamel.

Rose Webb outside The Hamel, c1930s.

Jim Loveridge was a well-known character, who lived at No. 29 New Christchurch Buildings.

Ferdinando and Anna Farina are remembered in the 'Italian area' of St Thomas's from around 1900 to 1941. Ferdinando was born in southern Italy, married Anna Cupaldi and they apparently walked to England c1900, setting up a common lodging house at 62–63 High Street, St Thomas's. Fred owned three beautifully painted barrel organs, which he rented out to Italians who would play around Oxford. The most popular was Joe Salvador who kept his rented organ in Faulkner's Yard.

Anna Farina devoted her life to looking after the down and outs in her common lodging houses. She was very popular and would help her lodgers by mending and making clothes for them. One of the Farina's employees, who acted as 'bouncer', is remembered as *a huge and gentle negro who had once made his living at fairs and circuses chewing glass and eating fire'*.

Fred died in 1937 and Anna in September 1941.

Anna Farina.

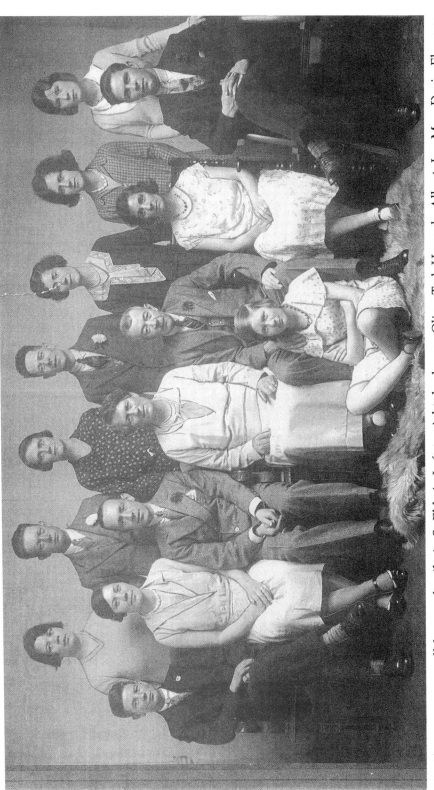

The Slopers were a well-known family in St Ebbe's. Left to right, back row: Olive, Ted, Hannah, Albert, Ivy May, Doris, Florence. Front row: Reg, Maud, William, Mrs Hannah Sarah Sloper, Mr William George Sloper, Ada, Les. In front: Evelyn. Hannah Sarah Ring used to walk from Wheatley to Oxford to see her future husband, William George Sloper, the trapeze artist, perform at the Oxford Institute. After their marriage, in the 1880s, William took a more down to earth job at the gas works and settled in St Ebbe's, first in Blackfriars Road, then in Pike Street, finally at 15 Dale Street on the banks of the Thames — 'the last house in the Friars, they called it'.

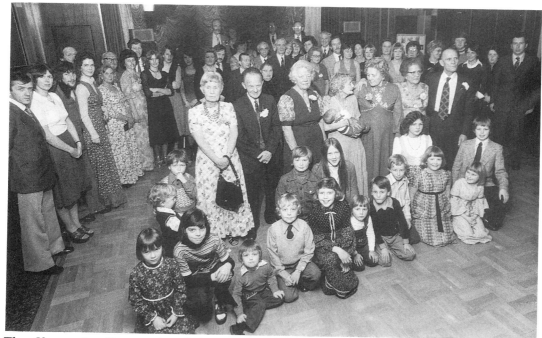

The Sloper family reunion held 25 February 1977, to which the eight surviving members of Hannah and William Sloper's thirteen children — Olive, Doris, Florence, Reg, Maud, Ada, Les and Evelyn — were guests of honour.

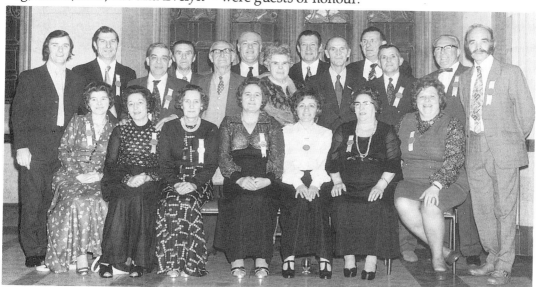

Members of the Friars Reunion Committee c1975. Left to right, back row: —, Ken North, —, Mr Purvey, Carlo Marchetti snr, Norman Wells, Nellie Jackson, Tony Stowell, Les Sloper, Len Hook, —, Mr Denton, Eric Godfrey. Front row: Mrs North, Mrs Stowell, Vi Sloper, Olive Sloper, —, Mrs Purvey, Miss Reed. The last Friars Reunion was held in April 1983. Les Sloper remarked *'to my way of thinking, the Friars are one of the finest families that ever existed in England; the comradeship was unique, and there was nothing to compare with it outside the East End of London.'*

'The Friars coming home'. Vi King, Enid Edwards and Peggy Walker celebrate their reunion after moving into new houses built in Thames Street, St Ebbe's.

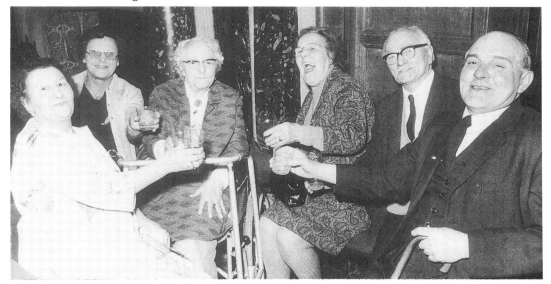

Tom-Rags Reunion 4 April 1975. Left to right: Mrs E Price, Mrs I Woodley, Mrs G Blackford, Mrs I Davis, Mr W Spencer and Mr H Faulkner, all residents of St Thomas's.

War Memorials

St Ebbe's Church

1914–18 War

Reg Baylis	Henry Cox	W E Giles
Albert Beckensall	Thomas Cripps	Robert Godfrey
Cyril Benson	Thomas Cudd	Frederick Green
Samuel Bond	A Dolton	William Greenwood
Albert Broadway	Percival Edens	Charles Griffin
Archibald Brocks	E Edwards	Harry Hall
Albert Broughton	Walter Evans	C E Haynes
Ernest Buckland	William Faulkner	James Haynes
Charles Burley	Sid Gardner	Harry Holland
James Burley	Harry Gibbons	Frank Hunt
Percy Campbell	Arthur Giles	Harry Jones
Frederick Clarke		

1939–45 War

Frank Andrews	Albert Doman	Charles Norridge
George Ayres	Jack Dorrell	Frederick Stone
Frederick Batts	Charles Eustace	George Weller
Roy Couling	Ronald Jones	Ronald Winterbourne

Holy Trinity Church

1914–18 War

C J Adams	G W H Fisher	W J Piper
S Alder	G H Finche	F Purvey
E Arkell	W French	A Radburn
J Allday	H Grace	J Radbone
J Allen	G Greenwood	E J Read
A F Bennett	T H Gardiner	H F Rivers
I Bricknell	P C Giles	W Rowlings
L Blay	T Gaskins	G J Sutton
H Bradley	G T Hill	S Slatter
H Boswell	C Holloway	J Stroud
R C Bultitude	F W Hutchings	T E Stett
G A Brown	F W B Hunt	G Saunders
G Brooker	F W Hall	H J Stockford
L Baxter	A D Higgins	W T Simmonds
P E Brogden	J C Hopkins	R W Stevens
J T Best	W Hitchman	A Tedder
J R Broom	T C Ingram	J Trinder
J A Cowles	H Jones	J F Thompson
A Church	C H Haycock	W B Turner
W J Clack	A Jackson	W Turner
W W Cox	H Killbee	G Tyrell
P Cechini	R Knibbs	H Trinder
R W Cowles	A V Long	T T Webber
S C Couling	A Marchetti	A L Wilkins
J H Clements	J Murphy	R J W Wakelin
G Calcutt	A E Masters	C White
A Dean	W E Moulder	W Walton
W Dean	W H J Markham	Watts
D Drewitt	R J Norgrove	W Wood
J T Fisher	J B Palmer	J Wilkins

1939–45 War

Frank Andrews	H W Mold	A H Stewart
H T Hathaway	D Read	C P Watts
W E Lambourne	J Sims	G P Weller
T H G Langstone	K D J Sloper	J C Woodward

Buildings and Views

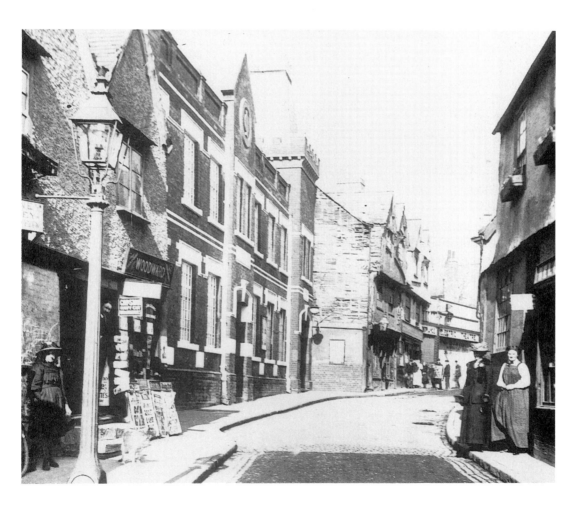

Castle Street looking towards Queen Street. The lower end of Castle Street was the site of the medieval New Market, the West Gate, demolished c1610, and the Castle Barbican of 1216. On the left is the Salvation Army Citadel built in 1888. Castle Street was realigned during the building of the Westgate Shopping Centre, but several 18th century buildings survived.

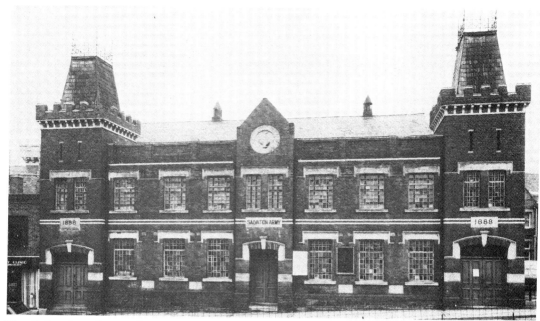

The Salvation Army Citadel built 1888 in Castle Street, designed by E J Sherwood to hold 1000 persons. The building was opened by William Booth. The first headquarters had been established in Sadler Street, St Ebbe's, and a disused rag mill in Friars Street was apparently also used for services during the early 1880s. The citadel was demolished in 1972 and replaced by a Community Service Centre in Albion Place.

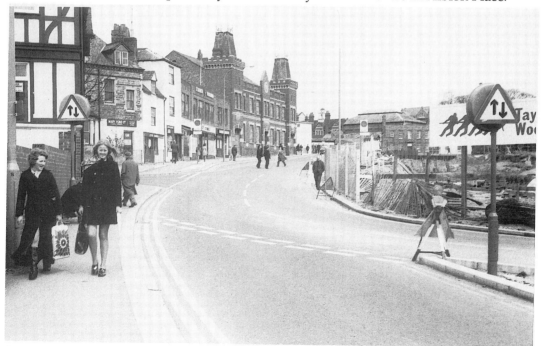

Castle Street in 1970 with the Salvation Army Citadel still standing. Work is progressing on the Westgate Centre on the right.

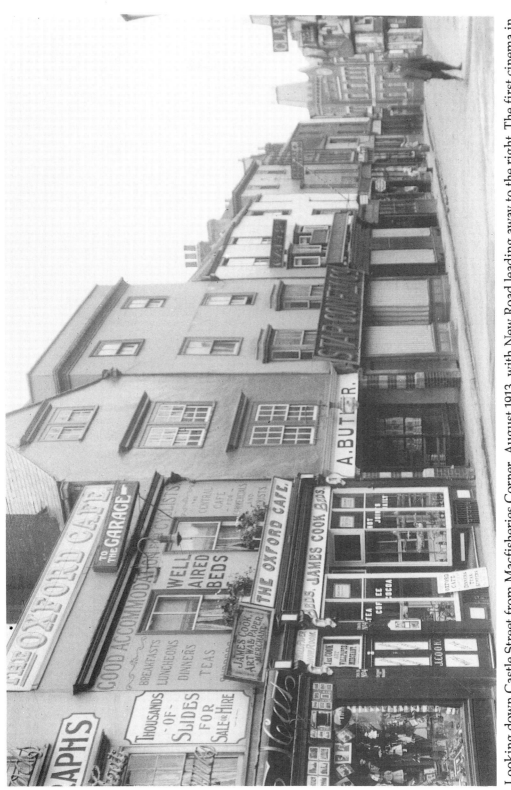

Looking down Castle Street from Macfisheries Corner, August 1913, with New Road leading away to the right. The first cinema in Oxford, the Electric, later the Picturedrome, opened in 1910 in an old public wash-house in Castle Street. This had closed by 1925. (The Bodleian Library, Oxford)

New Road looking towards Macfisheries Corner. New Road contained many small shops and businesses, including the Swan and Castle public house.

Paradise Street in 1970. The street was widened in 1885 when Castle Terrace and the half-timbered Paradise House public house were built. The ornate moulding above the gateway on the left leads into Greyfriars, a building dating from the late 17th century. The building in the far distance is Telephone House.

The former Atkins bakehouse in Blackfriars Road, just before demolition. *'There used to be a shop down the end of Blackfriars Road, Atkins it was, where you could get rice pudding in thick cakes to take away. There were big jars on a shelf along the back of the shop and one contained black treacle, real thick stuff that you could cut off with a pair of scissors to stop the flow.'* Extract from *Farewell St Ebbe's.*

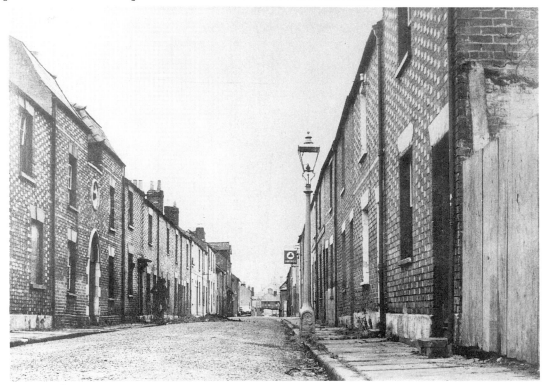

Blackfriars Road, with the sign of the Beehive public house visible on the right-hand side. The first house on the right was owned by a person known as 'Cattie', the owner of lots of cats!

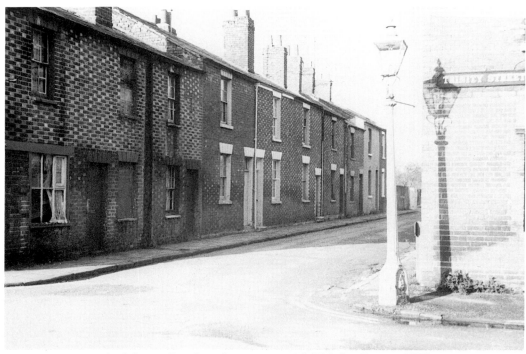

Blackfriars Road at the corner with Trinity Street, 1970.

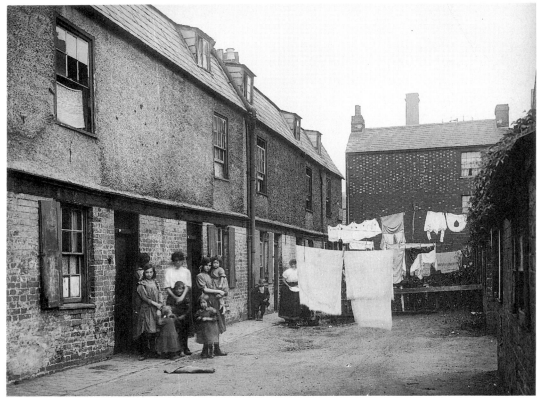

Waterloo Buildings, off Blackfriars Road, in 1914.

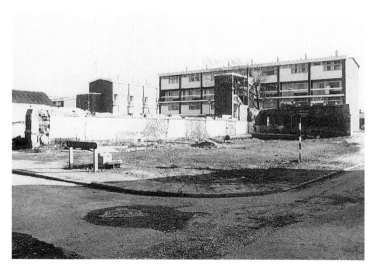

Blackfriars Road nearing complete demolition with the new maisonettes in the background.

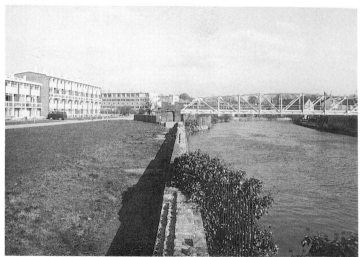

These maisonettes and flats, in Preachers Lane and Friars Wharf, backed onto the river, and were the first part of the St Ebbe's redevelopment in 1962.

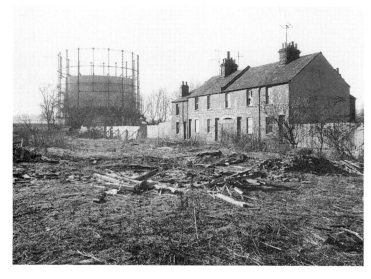

Blackfriars Road with the last remaining houses and the gasometer in the background.

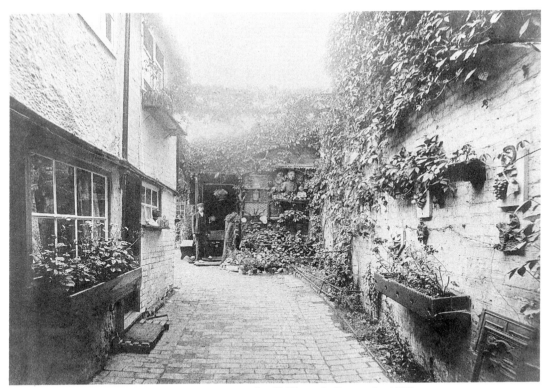

A picturesque yard off Church Street in 1901.

A very different scene in Norfolk Street during demolition in the late 1960s.

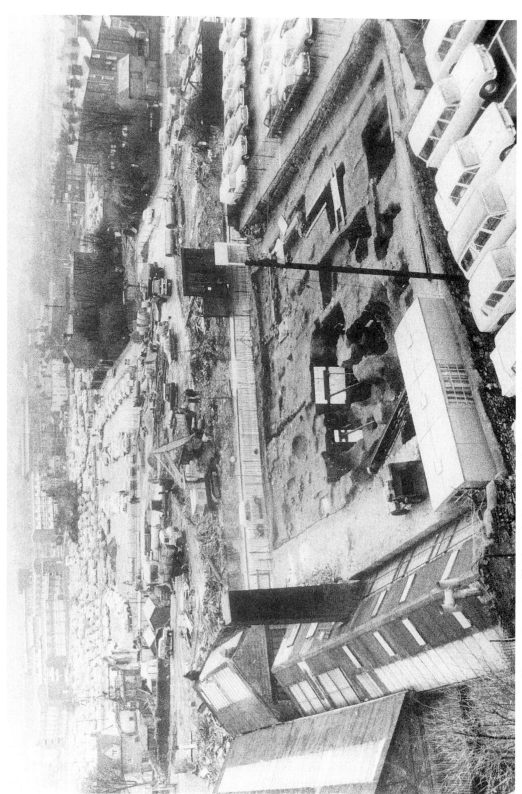

Excavation site off Church Street, with the rest of St Ebbe's turned over to temporary car parking.

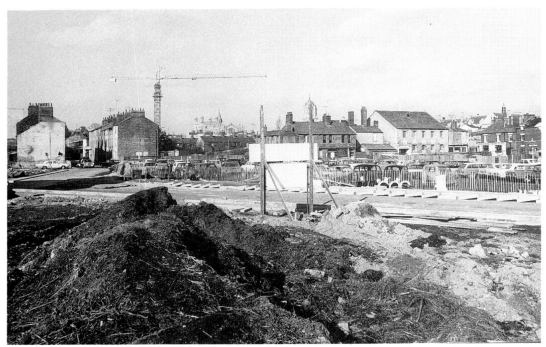

A view across St Ebbe's with Speedwell Street on the right-hand side.

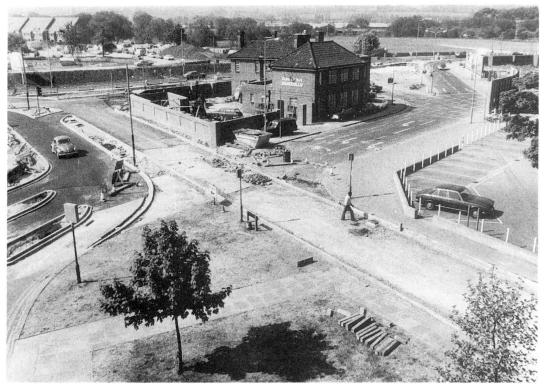

The Duke of York public house stands in splendid isolation in the shadow of the Westgate multi-storey car park, during construction of the new road system.

St Thomas's High Street, 1971, with the Mission Hall on the left. The Mission Hall, and
Sunday School classroom, was built in 1893 for the New Road Baptist Church. By 1912
the Mission had only eleven members, and closed before 1940 when the site was sold.

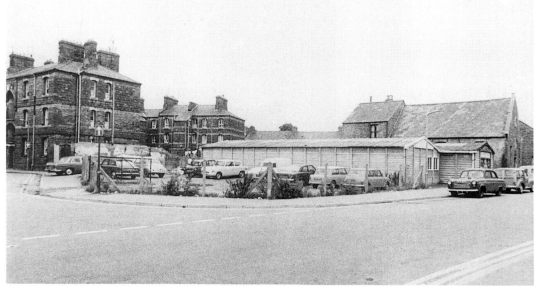

The Mission Hall on the extreme right-hand side, with Old Christchurch Buildings.
The mission was used for a time as storage for Wards, the department store in Park End
Street.

Quaking Bridge in 1975, looking towards Tidmarsh Lane with the mound of Oxford Castle behind. The name, Quaking Bridge, is first recorded in 1297, and was probably a description of its precarious state. On the left-hand side is Lower Fisher Row.

Old Christchurch Buildings in 1969, taken from the alley-way which lead to St Thomas's Recreation Ground and later the Oxpens Cattle Market.

Fisher Row began to develop in the early 17th century upon the Wareham Bank which was perhaps created during the construction of the Weir Stream centuries before. From its earliest days, it was home to bargemen, from nearby wharves, and for fishermen who supplied the local market with freshwater fish. Some of the 17th century houses, with 18th and 19th century additions, survived until 1954, when the Row was largely cleared. No. 1 Fisher Row, on the corner of St Thomas's Street is a three-storey brick house of the late 18th century build for Alderman Edward Tawney, Mayor of Oxford in 1797. Tawney was also responsible for the two adjacent alms houses and left sufficient money to keep three poor men and three poor women ... *reduced in*

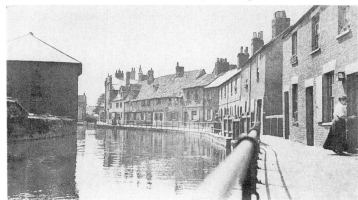

circumstances, single and unmarried, and of 50 years of age at the least ... they should be of the established church, and regularly attend divine worship at the parish church of St Thomas's.

Lower Fisher Row.

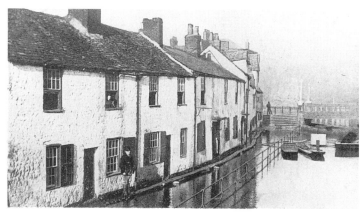

Middle Fisher Row.

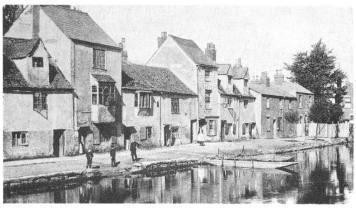

Upper Fisher Row.

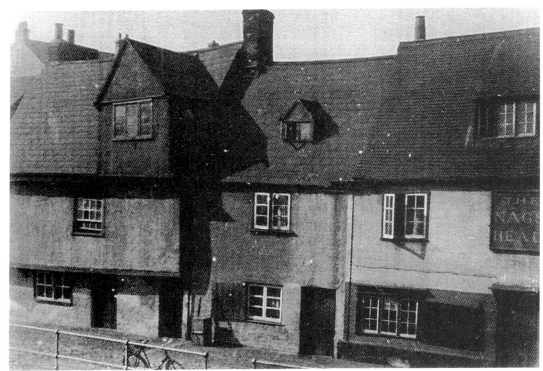

The Nags Head in Middle Fisher Row in 1933.

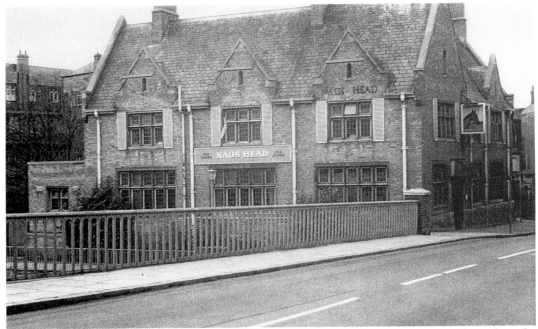

After the decline of Fisher Row, the Nags Head was enlarged and altered so that the entrance door was on Hythe Bridge Street. Seen here in March 1968. This is still a public house and has taken the name of Antiquity Hall, which used to stand in Hythe Bridge Street.

Oxford Castle and Mill

Oxford Castle, built by Robert d'Oilly after the Norman Conquest, was a royal residence and garrison. The Castle followed the classic figure of eight shape, known as the Motte and Bailey. The Mound or Motte still survives, while the shape of the Bailey and the line taken by the Moat which surrounded both can also be detected. In 1142, during the Civil War between King Stephen and the Empress Matilda, the King besieged Matilda in the Castle for three months, having first captured the town. Matilda's escape was recorded by a contemporary, Henry of Huntingdon, *'not long before Christmas Day, the Empress escaped across the frozen Thames, dressed in a white garment, tricking the eyes of the besiegers by her white clothes in the dazzle of the snow'*. The Castle was again under attack in the Barons' War of 1215 and, shortly afterwards, siege works were built. These consisted of two earthen mounds which were known subsequently as Mount Pelham, which was levelled c1650, and the Jews Mount destroyed when the canal was constructed in 1790.

From the middle of the fourteenth century the Castle fell into decay and it ceased to have a military function. It did remain useful as a gaol and assizes were held there up to 1577 when gaol fever developed during the trial of Rowland Jenkes, and, it is said, subsequently claimed the lives of over three hundred people. During the Civil War the Castle was garrisoned by the Royalists and in 1649 it was refortified by the Commonwealth Army which resulted in the levelling of most of the wall towers.

In 1776 New Road was built across the northern part of the Bailey, and in 1785 the site was acquired for the building of a County Gaol. Five years later the construction of the canal terminus completed the in-filling of the ditch. The building of County Hall in 1841, the Militia Armoury in 1854 (from 1876 used as the Oxfordshire Constabulary Headquarters) and the extended prison in 1856 completely obscured the site.

In the twentieth century further buildings were erected, including the County Education Offices in 1912, on a site previously occupied by the Parochial School of St Peter le Bailey and before that the City Pound. Nuffield College replaced the canal terminus in 1959, leaving only the canal offices. Ten years later Macclesfield House was built on the site of the Militia Armoury.

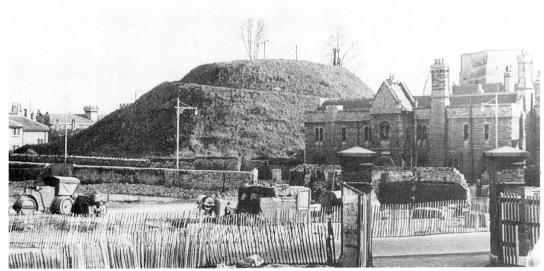

The Mound in 1955, with a few trees still standing. The Motte, or Mound, of Oxford Castle still survives in New Road. The Mound is artificial, constructed c1071 from material dug out of the surrounding Castle Moat. It stands over 80 feet above the level of New Road, with a diameter of about 250 feet across its base and over 60 feet at the top. The Mound originally included a tall wooden tower, dominating the main route into the City from the west.

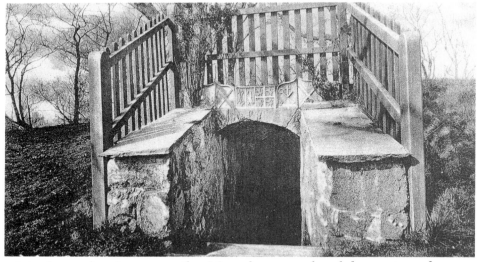

The original wooden tower on the Mound was replaced by a stone keep, which survived until at least c1663. Today no trace of the footings of this keep can be seen above ground, but its Well Chamber is still accessible. This is reached by a flight of steps leading down about 20 feet below the top of the mound. At the entrance to the Chamber are three stones bearing ecclesiastic shield-of-arms. The Chamber dates from the early thirteen century and is hexagonal with a stone vaulted roof. At the end of the eighteen century the well was cleared out and found to contain, amongst other things, human skeletons, possibly the remains of criminals publicly executed.

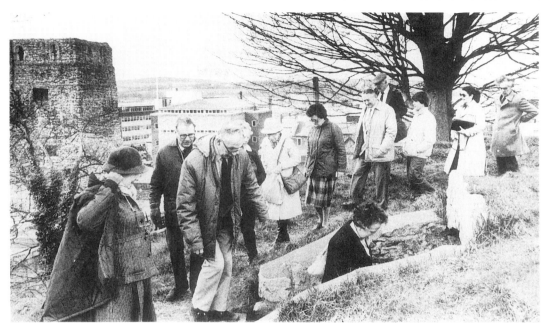

The Mound and the Well Chamber have been mainly inaccessible due to their proximity to Oxford Prison. This party in 1989, members of the Guild of Oxford Guides, was led by Len Barnes, Oxfordshire County Council's countryside projects officer.

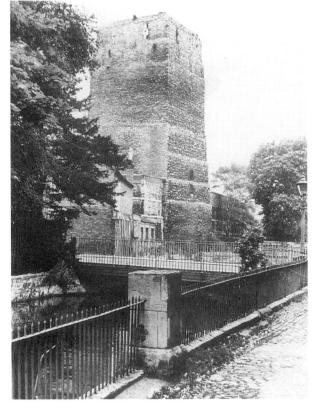

St George's Tower is believed to be the earliest stone building in the Castle, dating from c1074, originally part of the church of St George's in the Castle. The Tower is four storeys high with nine feet thick walls at ground level. The early rampart round the Bailey was replaced by a stone curtain wall with towers at intervals. The earliest plans of the Castle show that in 1578 there were five other wall towers apart from St George's.

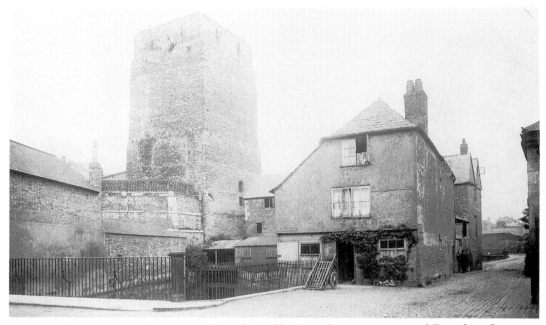

A view of St George's Tower and Castle Mill. Note the narrowing of Paradise Street on the right-hand side.

Castle Mill 1920. At the foot of St George's Tower on its western side are sluice gates which mark the site of the Castle Mill. A mill was established here by 1086 and survived until a road widening scheme in 1930. It served a double function of a water mill for grinding corn, and also of a dam which could control the level of water entering the Castle Moat. The early mill had two wheels, one of which was granted to the citizens of Oxford in 1199 when they acquired the right to collect their own taxes. The other half of the mill remained in the King's possession and was transferred to the Bishop of Oxford in 1542 after the Reformation. The City bought this part of the mill in 1591.

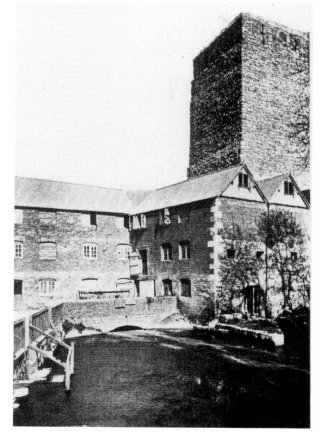

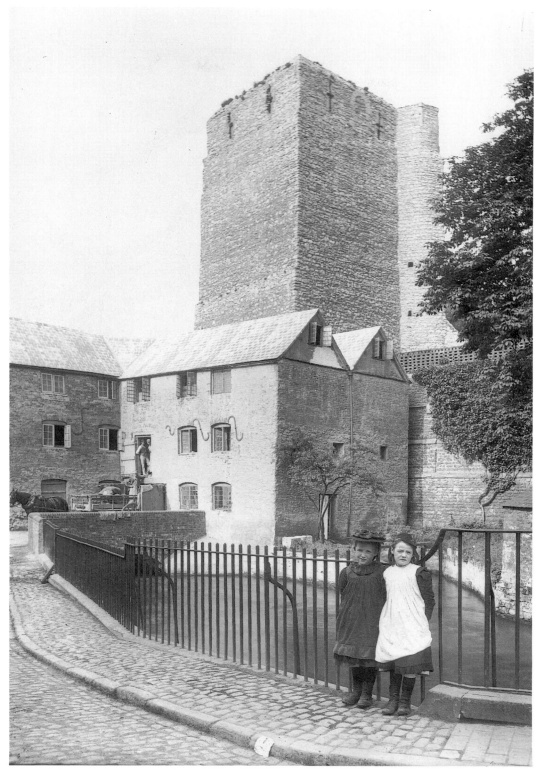

St George's Tower and Castle Mill c1912. (The Bodleian Library, Oxford, Ref 17/3, Minns Collection)

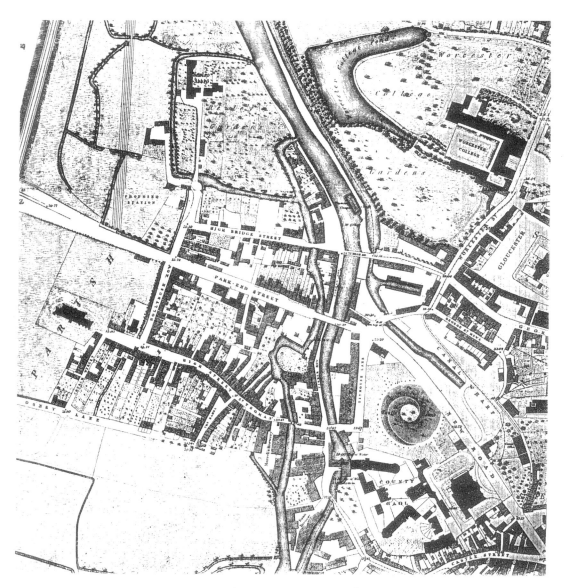

Extract from Hoggar map of 1850.